1936

19

1939

1948

1949

1950

1953

1954

1968

1989

7/2349040

Dalí's Moustaches

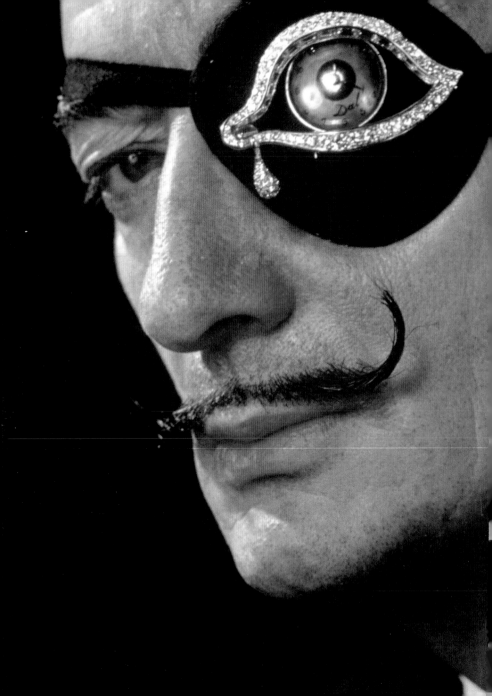

BORIS FRIEDEWALD

Dalí's Moustaches

AN ACT OF HOMAGE

PRESTEL

MUNICH · LONDON · NEW YORK

Contents

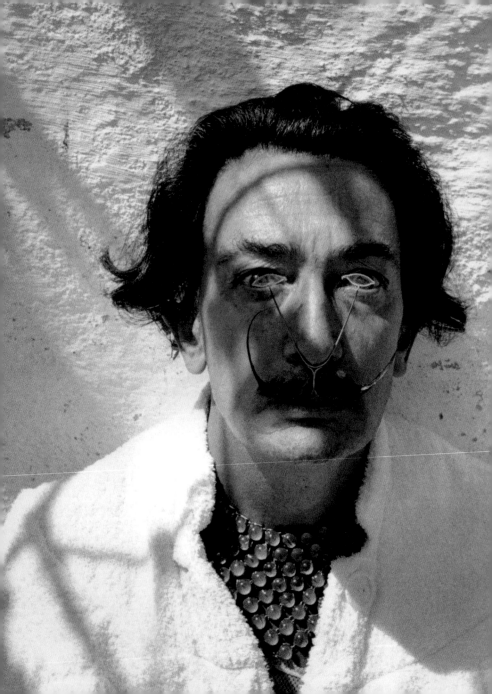

The Multiple Lives of Salvador Dalí

I call on young painters to follow my example
to either be reborn or die.
S.D.

Rome, summer 1954: The Palazzo Pallavicini-Rospigliosi is showing a large Dalí retrospective. Before a mob of waiting journalists, a flap opens in a cube and He appears: the divine genius, the eccentric jester, the magician and charlatan, the madman, the masterly painter.

He could be many things, but there was one thing he truly yearned to be, and that was Dalí. The cube, which was inscribed with the letters of the alphabet, was not a random choice, nor was the date for this event: June 1, 1954. If we add up the numbers for this date (6+1+1+9+5+4), we arrive at twenty-six. The numerological value of the name Dalí (4+1+12+9) is also twenty-six. And it is no accident that, for this rebirth, Dalí chose to emerge from a cube. A cube has eight corners, twelve edges, and six surfaces, and the sum of these numbers is also twenty-six. It was a truly Dalínian day. **[fig. p. 9]**

A short while later Dalí explained, "It is extremely difficult to first see the light of day when you already have a moustache [...]. That is why I traveled to Rome, in order to be 'reborn' with my moustache." His emergence from the cube symbolized his fourth birth, which meant nothing more than that Dalí had finally and completely

Charles Hewitt for Picture Post (from: "A Day with Salvador Dalí"), *Salvador Dalí with necklace and face holder*, 1955

become Dalí—the artist with the unmistakable moustache, which now definitively made him unique, for it measured 25 centimeters: the longest it had ever been.

It had been a long journey. The first Salvador Dalí was born on October 12, 1901, to the notary Don Salvador Dalí y Cusí and his wife Felipa Domènech Ferrés. The child must have radiated an unusual beauty and charm. But this Salvador died just twenty-one months after his birth. The cause of death may have been meningitis, or possibly a gastrointestinal infection as is written on the death certificate. On May 11, 1904, nine months after his death, Felipa Domènech Ferrés gave birth to another child. It was a boy, and the parents again named him Salvador. This was the second birth of Salvador Dalí, for his parents saw him as a reincarnation of their first son. The new Salvador wore the old Salvador's clothes, played with his toys, and was like a mirror of his dead brother. When mother and son went for a walk, she would say, "The other one always sneezed when he passed here, so be careful." Many years later, Dalí said in an interview, "I have often thought that my brother was a failed attempt at making me." At age three, Salvador wanted to be a cook; at age six, dressed in a royal robe that had been a gift from his parents, he pretended to be Napoleon. He later recalled that "dressing up was one of the great passions of my childhood."

But the other Salvador was always present, and was both his God and his greatest enemy. As a student, Dalí wanted to look like an artist, to be Raphael, and so he resolved to turn his head into a work of art. He decided to grow sideburns, which were followed later by a Menjou moustache, for in his view the American silent film star Adolphe Menjou was a true Surrealist. When Dalí was admitted into the Surrealist group in 1929, it was as if he had been born again—for the third time. At the time, he wore a Menjou moustache.

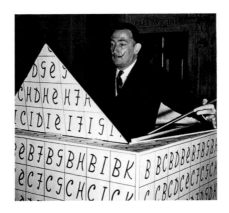

Above all, however, Dalí saw his whiskers as a sign of his talent and creativity. They were a protective shield that masked his personality, but they were also a direct expression of this personality. They were his artistic material and his instantly recognizable trademark. And much more. Dalí lived a whole life before his fourth birth in Rome, but it was very different from his life before birth—from the time in his mother's womb that he could remember so well. He never ceased to give birth to new ideas from his delirium, his delusions, and his dreams. Through his muse and goddess Gala, Dalí felt himself to be masculine and feminine all at once. Had he not fled war-torn Europe for America in 1942, the forthcoming birth of his new identity would have been endangered, because "I would have run the risk of dying before being born." In America, his moustache began to grow and grow until he decided to twirl its ends upwards. But it was more than just a moustache: infinitely more. And that is the story of this book.

Ezio Vitale, Salvador Dalí emerges from a
"Metaphysical Cube" on June 1, 1954, at a press
conference in the Palazzo Pallavicini, Rome

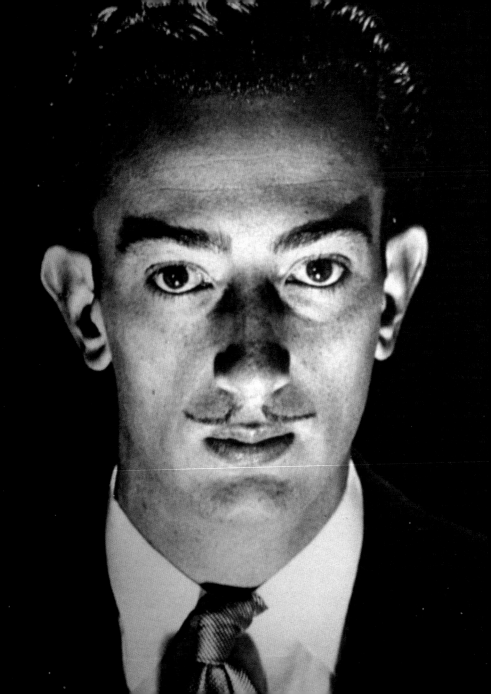

Hairy Beginnings

I became a genius
because I pretended to be one.
S.D.

When he was eight years old, Salvador still had two baby teeth—
the two lower central incisors. He would never lose them, and
many years later he wrote, "the chaos of my teeth, my extremely
underdeveloped chin [...] exist in a mythical correlation. [...] Already
as a youth, I discovered that one of them sheltered the Virgin of
Lourdes." During his childhood in Figueres, the city of his birth,
going to school was the last thing he was interested in. But when
he looked out the classroom window, he saw two cypresses that
reminded him of two flames consuming themselves. Cypresses
would later be a recurring motif in his paintings. And if he looked
up at the classroom ceiling, an entire world opened up before him:
a spot became a cloud, then a human figure, then an object. And
when the door to the classroom was left open, he could see the
reproductions of two paintings. One of them was Jean-François
Millet's *The Angelus*. He would never forget it.

Also at the age of eight, Salvador had his first art studio—an
old laundry room in the attic of the house where he lived with
his parents and younger sister. In the studio was a giant cement
laundry tray, into which Salvador placed a chair. This is where he
painted. When the studio got too hot in the summer, he filled the
tray with water, took off his clothes, and used a wooden board

Man Ray, *Salvador Dalí*, 1929

as a desktop. If we are to believe the fantastical stories in Dalí's book *The Secret Life of Salvador Dalí*, then this was where "the first pinches of salt and the first grains of pepper of my humor were born. I began already to test and to observe myself while accompanying my voluptuous eye-winks with a faint malicious smile, and I was vaguely, confusedly aware that I was in the process of playing a genius. O, Salvador Dalí! You know it now! If you play at being a genius, you become one!"

In 1916, Don Salvador Dalí y Cusí sent his son Salvador to the Instituto, a school at which students worked towards their *bachillerato*, the school-leaving degree that is a requirement for attending a university. Around the same time, a friend of the family was amazed at the twelve-year-old's unusual paintings and, convinced the boy was a genius, told his father that Salvador needed to take drawing lessons. And so Salvador's father signed him up for evening classes at the local drawing school in Figueres, whose director Juan Núñez Fernández was also the art teacher at the Instituto.

Salvador learned from his teacher, but his teacher also learned from him—usually when Salvador did the exact opposite of what Señor Núñez had given him as an assignment. Once, Dalí was supposed to draw an old beggar man with a long, curly white beard. But Núñez was not satisfied with his pupil's work, because the beard, instead of being light and wispy, looked much too dark and massive. He asked Salvador to try again, this time with more respect for the white of the paper so that he might give the beard a more realistic feel. His teacher also asked him to use a softer pencil and to draw using lighter strokes. Salvador did the opposite: he took the thickest and darkest pencil and drew so wildly that the entire page was soon filled with a uniform black color. Señor Núñez was aghast, but Salvador pulled out a small pocket knife

and scratched away at the pencil drawing to reveal a portrait of the beggar using the white of the page. If something struck him as too light, he smeared the color with his own saliva. For the beard, he not only scratched away the graphite with his knife until it shone brightly, but he also plucked out the paper fibers with his fingernails and twisted them into tiny curls. When he used a lamp to illuminate the paper from the side, the beggar's beard took on a realistic three-dimensional feel. Overjoyed, his teacher threw his arms around the pupil and told Salvador's father that the boy had to become a painter. By then, of course, Salvador had made the same decision on his own.

In 1920, the sixteen-year-old Salvador wrote in his diary: "The highpoint of and perhaps the most important, because the most direction-giving, thing in my life is the following decision (approved by my family): to quickly complete school. [...] I will go to Madrid, to the Fine Arts Academy. I think I will spend three years there working madly. [...] If I sacrifice and really put myself to the test, I will earn enough to spend four years in Rome: And when I return from Rome, I will be a genius and the world will admire me. I may be despised and misunderstood, but I'll be a genius, a great genius, because I am sure of it."

But before beginning his studies at the San Fernando Academy in Madrid, he felt driven to change his appearance: "As soon as possible I wanted to make myself 'look unusual,' to compose a masterpiece with my head." Dalí didn't just want to be an artist; he wanted to look like one. And since his ideal artist at the time was the Renaissance painter Raphael, he decided to look just like him. He grew his hair long and practiced Raphael's "melancholy look" in front of the mirror, but the most important element was still missing: facial hair. "I was also waiting impatiently for the

down on my face to grow, so that I could shave and have long side-whiskers."

In 1921, when he was seventeen, Dalí painted a self-portrait that he called *Self-Portrait with Raphaelesque Neck.* **[fig. p. 15]** It shows the artist with sideburns almost down to his jawline, just as he had admired them in Raphael's self-portrait. This was his first beard, but he soon decided that his facial hair would take on entirely different dimensions. Dalí made this decision after devouring Nietzsche's *Thus Spoke Zarathustra* in just three days. Although the book confirmed many of his beliefs, he also felt great contempt towards Nietzsche, and he resolved to one day outdo the great philosopher—in terms of facial hair as well. The Raphaelesque sideburns were just the beginning.

In 1922, one year after his mother's death from cancer, Dalí began to study painting at the San Fernando Academy in Madrid. For the next few years, his home was the Residencia de Estudiantes, a residence for students, professors, and artists. It was more than just a place to rest one's head: the Residencia organized lectures and concerts, and there was a library as well. Dalí immediately stood out because of his appearance. Unlike his short-haired housemates, who wore tailor-made suits or fashionable coats, his hair reached down to his shoulders and he wore velvet coats with shorts, and a scarf tied in a bow around his neck. When it rained, he never ventured out without a floor-length cape and a large felt hat. This was also when he first began carrying a walking stick with a golden handle—an accessory that, later in life, would be like an extension of his body. He also carried a pipe in his mouth that he never lit, and he proudly displayed his sideburns. As a result, he was an object of ridicule at the Residencia, where one of his nicknames was "the artist." It was not meant in a friendly manner. Nevertheless, soon

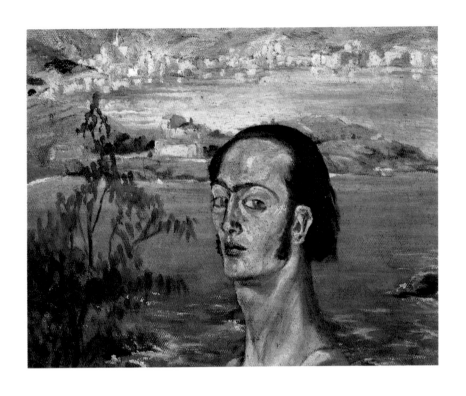

Salvador Dalí, *Self-Portrait with Raphaelesque Neck*, 1921

he prized this community of students more than his studies. The Academy's liberal atmosphere encouraged students to discover and develop their own abilities, but Dalí wanted to learn techniques and clear rules; he sought strictness and discipline.

Dalí's room was also his studio where he spent every free minute painting. On Sundays, he copied paintings at the Prado. Whenever he left his room, a small group of students would gather to ridicule him. Once, the maid forgot to lock the door to Dalí's room, and the medical student Pepin Bello caught a glimpse of his works. The news spread like wildfire: Dalí was a Cubist! From now on, students were constantly knocking on Dalí's door to admire his works. Besides the paintings, there were countless drawings, many of them strewn across the floor of his room. One drawing showed two clumps of hair wearing the hats of the Guardia Civil. Dalí explained that it showed two policemen lovingly pressing their moustaches together. Another drawing—a horizontal line intersected by a vertical line topped by a moustache—was supposed to depict the kind of petit-bourgeois philistine sitting at a café table whom he despised so much.

Suddenly, everyone wanted to be friends with this shy eccentric. But his most important friends, who had a significant influence on his future path in life, were Luis Buñuel, a student of engineering, literature, and philosophy with an interest in entomology who enjoyed boxing in his spare time, and Federico García Lorca, a student of law and literature who did little else but paint and write plays and poetry. They drank tea together, or double vermouth with olives. They discussed and accepted—and defended—Dalí's look. But Dalí had already decided to work on his next transformation: he cut his hair and slicked it back, first with varnish and then with egg white, and he bought himself a suit with a sky-blue silk shirt

and sapphire-studded cufflinks. From now on, he wanted to be a dandy. He attracted attention in this role as well, and not just through his new look. In the fall of 1923, Dalí was expelled from the Academy for an entire year because he had responded to the official announcement of a new art professor by standing up and leaving the room in protest. His expulsion led to wild and colorful protests on the part of the other students, and the school's president held Dalí responsible for the unrest.

Shortly after his expulsion, Dalí returned home to Figueres, where he was arrested on May 24 and spent several weeks in prison. Apparently, the authorities took him for an anarchist who had participated in the unrest that had followed King Alfonso XIII's visit to the Catalonian city of Girona. In September 1923, General Primo de Rivera had introduced a military dictatorship in Spain, with the support of King Alfonso. The effects of the dictatorship were quickly felt in Catalonia. Although he had previously confirmed Catalonian autonomy, Primo de Rivera banned the Catalonian flag, the national dance, and the use of Catalan in public. Afterwards, Dalí was convinced that he had been arrested because his father had reported a case of electoral fraud by the rightist party in Figueres. He also later said, "I should have liked to live in a prison."

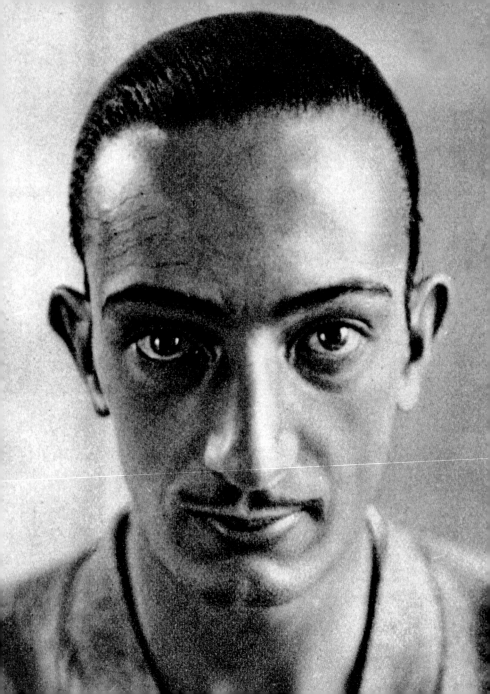

The Surreal Menjou Moustache

It is often said that the eyes
are the windows to the soul.
A moustache such as his can be the same.
Luis Buñuel

"I am very sorry, but I am infinitely more intelligent than these three professors, and I therefore refuse to be examined by them." With these words, Salvador Dalí took leave of the exam committee before which he was to take his oral end-of-year exam in the summer of 1926. Dalí was expelled from the Academy a second time, bringing his academic career to a definitive end. The young artist returned home to Figueres, where he continued to paint. Some of his works from this time show the influence of the Italian Metaphysical painters, others contain hints of Neo-Cubism or a tinge of Realism, and there are occasional traces of Surrealism as well. By this time, Dalí had already read several works by the psychoanalyst Sigmund Freud. He was especially fascinated by *The Interpretation of Dreams*, which he later called "one of the capital discoveries in my life, and I was seized with a real vice of self-interpretation, not only of my dreams but of everything that happened to me, however accidental it might seem at first glance."

During all this time, Dalí's exceptional friendship with Federico García Lorca grew ever stronger and greatly inspired the artistic endeavors of both the writing painter as well as the painting poet.

Unknown, *Salvador Dalí*, 1929

It was a relationship in which Dalí and Lorca repeatedly expressed their mutual love and devotion, but that was tested by Lorca's desire for physical intimacy.

In the fall of 1926, the Barcelona gallerist Josep Damrau exhibited several of Dalí's paintings alongside works by other Catalan artists. Thanks to this exhibition, the young artist was noticed by the art critic Sebastià Gasch, who wrote an article comparing Dalí's painting with the music of an American jazz band. The enthusiastic Dalí wrote to the critic: "Your article [...] interests me a lot since it relates my painting to one of my strongest predilections, jazz, that marvelously anti-artistic music."

"Anti-artistic"—this is how Dalí saw himself and his art, far removed from all earlier notions of art and artists. He and his work would turn everything on its head, would be different; the opposite or antithesis of all that had come before. In this vein, Dalí began to see "art" as a dirty word. In his letter to Gasch, he continues, "'Artistic'—horrible word that only serves to indicate things totally lacking in art. Artistic performance, artistic photography, artistic advertisement, artistic furniture. Horror! Horror! What we all like, on the other hand, is the purely industrial object, dancehalls and the quintessential poetry of Buster Keaton's hat."

In late summer 1927, Buñuel, Dalí, and Lorca met in Madrid. Dalí had been pressing Lorca to share his latest play with Buñuel, who had been watching the friendship between the painter and the poet with envy and ill will. Lorca read—but only until Buñuel slammed his hand on the table and proclaimed, "Federico, it's a piece of shit!" Lorca gave Dalí a pleading look, but his friend offered little consolation: "Buñuel is right. It's shit." This brief exchange was a sign that the friends had begun to grow apart, and the process now ran its inevitable course. Dalí considered Lorca's work unmodern,

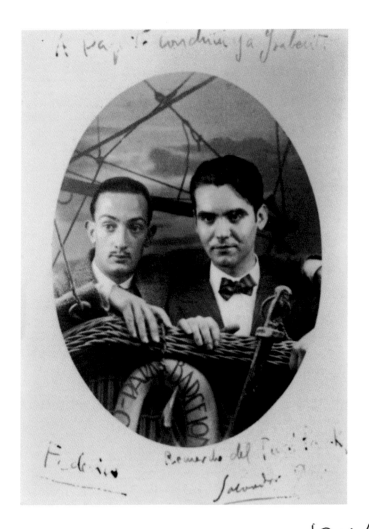

Unknown, *Salvador Dalí and
García Lorca*, ca. 1927

and increasingly felt that his friend's influence was nudging him in the wrong direction. More and more, he looked to Buñuel, whom he held to be modern and anti-artistic, for inspiration. And above all else, Dalí wanted to be modern. A self-portrait presumably made around this time reveals his vision of the future. The painting, which was dedicated to Lorca, shows Dalí with a pointy goatee—a kind of beard he never wore—but also with a moustache whose tips reach truly Dalínian heights. **[fig. p. 23]**

Both Dalí and Lorca had repeatedly explored the theme of St. Sebastian in their art. St. Sebastian was not only the patron saint of Cadaqués, a town in the province where Dalí's family owned a vacation home at which Lorca was a frequent guest, but also the patron of homoerotic love; he had become a symbol of the two men's relationship. In his 1927 essay *Saint Sebastian*, Dalí wrote of what he called an "aesthetics of objectivity." The essay was dedicated to Lorca.

The essay includes a scene with a barmaid who plays a blues song on the gramophone, a car race seen from an airplane, and hydroids with parachutes sinking to the bottom of an aquarium—to the rhythm of a Josephine Baker song. The essay is noteworthy because it is the first time that Dalí mentions Adolphe Menjou, the movie star who was of such singular importance to Dalí's changing relationship to his facial hair: "Adolphe Menjou, in an anti-transcendental ambience, offers us a new dimension of the dinner jacket and of ingenuousness (by this time enjoyable solely in cynicism)."

Adolphe Menjou (born 1890) had become famous through Charlie Chaplin's 1923 silent film *A Woman of Paris*, thanks not just to his acting skills but also his looks: Menjou, who repeatedly portrayed the sophisticated bon vivant, was always elegantly dressed—and

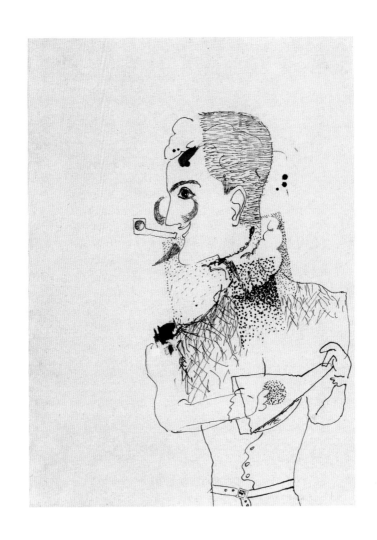

Salvador Dalí, *Self-Portrait* (dedicated
to Federico Garcia Lorca), 1926

always wore a thin moustache that would become his trademark. **[fig. p. 24]** His female fans were not the only ones enamored by his moustache. In *A Woman of Paris*, which Dalí must surely have been familiar with, a man and woman fall in love, but their love has no future because it is not accepted by their provincial families. And so the couple plans to elope to the city, to Paris, where everything seems possible. But on the day of their departure, the woman's lover does not arrive at the train station, and so she leaves for the city of dreams on her own, where she becomes the mistress of a rich playboy, portrayed by Adolphe Menjou.

A short time after writing *Saint Sebastian*, Dalí grew a thin moustache on his upper lip (he had shaved off his sideburns quite some time before)—the first subtle hints of a Menjou moustache. **[fig. p. 18]**

The ill-fated lovers from Chaplin's film were not the only ones to dream of Paris. It was the city of dreams for the young Dalí as well: the place where he felt fame awaited him. Paris was also the home of Luis Buñuel. The two friends had never lost contact since

Unknown, *Adolphe Menjou*,
1920s

their time together at the Residencia, and their friendship had grown since the summer of 1927. Buñuel had gone on to study acting at the Académie de Cinéma in Paris, had written his first screenplays and theater pieces, worked as an assistant in film, staged a short opera, and met with the Surrealists. He also went to the movies three times a day and regularly wrote essays on cinema. In 1927, he wrote an article for the French art and literature review *Cahiers d'art* entitled *Variations on Menjou*—a humorous homage to the famous Menjou moustache, the one that his friend Dalí had begun to grow as well. An expanded version of the article appeared the following year in Spain under the title *Variations on Menjou's Mustache.*

In the essay, Buñuel wrote: "Observing him in whichever of those realities, we see in Menjou himself the most extraordinary Menjou that art, literature, or cinema could offer. [...] Who doesn't know, moreover, that just as the sirens have their song, so his great Menjouesque powers radiate from his mustache, that brilliant mustache of the movies? [...] It is often said that the eyes are windows into the soul. A mustache like his can be as well. As he leans so often in close-ups above our heads, what can his eyes tell us that his mustache hasn't already said? A trivial gesture or an almost imperceptible smile acquires, beneath the magic shadow of the mustache, an extraordinary expressiveness; a page of Proust brought to life on the upper lip; a silent but nevertheless comprehensive lesson in irony. Had he not guarded against it, 'copyrighting' his mustache, irony would have become standardized, within reach of the most humble of faces. In the display windows of the future. Menjou's mustache, which embodies the cinema of his time, will replace Napoléon's insufferable and inexpressive hat."

In December 1927 Dalí wrote the essay *Art Film, Antiartistic Film,* this time dedicated to his friend Buñuel. In it, he came out

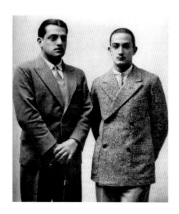

strongly against what was then generally understood as "artistic film," explaining that "in the other more or less artistic cinema productions, the beginnings of fatigue, boredom and sadness characteristic of the artistic phenomenon are immediately felt; only anti-artistic cinema, and more particularly, comic cinema, produces films which are more and more perfect, where emotion is more immediately intense and amusing." And: "The anti-artistic filmmaker is unaware of art; he films in a pure way, obeying only the technical imperatives of his camera and the childish and very merry instinct of his sporty philosophy. The artistic filmmaker's knowledge of art is almost always crude and he obeys the sentimental arbitrariness of his genius. The anti-artistic filmmaker limits himself to psychological, primary, constant, standardized emotions, aiming thereby to suppress anecdote. When monotony is reached and repeated, when you know what is going to happen, then you begin to feel the unhoped-for joy of technical and expressive diversity." He then emphasizes that "the anti-artistic director achieves constant action and signs," and gives an

Unknown, *Luis Buñuel and Salvador Dalí*, ca. 1929

example: "The good guy's shaven face; the bad guy's thin, sharp moustache."

This enthusiasm for anti-art was a harbinger of the Dalí we know so well: the Surrealist with the Menjou moustache. The following year, Dalí clearly showed his dark side. In the *Yellow Manifesto*, he condemned the provincial nature of Catalan culture, and spit on folklore and tradition. Never again would he be entirely beardless, and his moustache took on an increasingly sharper form.

Meanwhile, Buñuel associated increasingly with the Surrealists, and in January 1929 he was made a full member of their group. No other member was as obsessed with film and with the desire to make a Surrealist film as Buñuel. In January 1929, his first film project had just failed because it lacked a script, and so he travelled to Figueres in order to collaborate with Dalí on a new project. **[fig. p. 26]** The two friends told each other their dreams: Dalí spoke of ants crawling out of his hand, Buñuel of cutting open an eye. Such were the beginnings of their screenplay, which they wrote together over the course of six days. Today, many cinema encyclopedias consider *Un Chien Andalou* the only truly Surrealist film. Shortly before starting to shoot their film in Paris in April 1929, Dalí interviewed his friend Buñuel for the Catalan art review *L'Amic de les Arts*. In the interview, Buñuel explains that the American actor Harry A. Pollard, the silent comic Ben Turpin, and Adolphe Menjou were greater Surrealists than Man Ray, even though Ray was an official member of the Surrealist group.

The same issue of the magazine also published several of Dalí's essays. In one of these, he wrote, "Menjou's mustache, in the same film, could be placed on the cornice of a building without any special effects, like a swallow." In another interview with Buñuel,

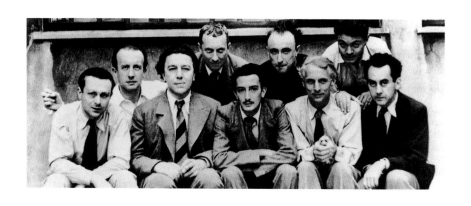

Man Ray, *Salvador Dalí among
the Surrealists* (from left to right: Tristan Tzara,
Paul Éluard, André Breton, Hans Arp,
Salvador Dalí, Yves Tanguy, Max Ernst, René
Crevel, Man Ray), ca. 1930

published in March 1929, Dalí asked, "Would the influence of the Surrealists be of service to you in modifying and liberating Menjou's mustache?" Buñuel answered, "This remains to be seen. [...] I continue to be very preoccupied with these incessant escapes, whose trail I follow very closely. Just now you'll find me extremely intrigued by the question whether his mustache is male or female. I am confident that I'll find out about this much better with you." A short time later, Dalí was accepted in the Surrealist group and moved to Paris. **[fig. p. 28]**

The Surrealist author Louis Aragon once said that the "veritable initiator of the modern marvelous" was the nineteenth-century poet Lautréamont, the great idol of Dalí and the Surrealists. When Lautreámont wrote that something was "as beautiful as the chance encounter of a sewing machine and an umbrella on a dissecting table," it is as if he was describing a Surrealist object. Everyday objects had to be stripped of their usual function and placed in new contexts so that they could, as surreal objects, let the marvelous unfold.

Dalí wanted to do more than just place the Menjou moustache on a cornice; he placed several specimens in a cigarette case and politely offered them to his friends. Apparently, nobody ever took him up on the offer. For Dalí, the Menjou moustache had become a Surrealist object. And the more his own Menjou moustache grew, the more Dalí not only became a Surrealist, but he also increasingly and more directly became the physical embodiment of Surrealism.

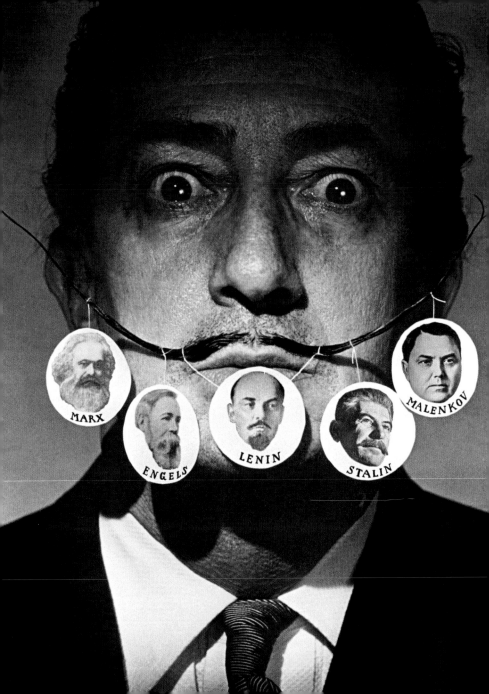

Communist Beards

The capillary tristesse of Communism
is another omen of its inevitable decline.
S.D.

In June 1935, the author René Crevel committed suicide, just a few months shy of his thirty-fifth birthday. Dalí saw the death of the poet, who had been as passionate about communism as he had been about Surrealism, as a sign: "A most terrible evidence of the fundamental incompatibility between politics and poetry."

Just a few months after the first *Surrealist Manifesto* was published in 1924, the Surrealist group engaged in intense debate on the importance of politics for the realization of their goals. The manifesto had said nothing about politics. In the text, its author André Breton had condemned a world governed by reason and "the reign of logic", in which the "depths of our mind" had been increasingly suppressed. He praised Sigmund Freud, thanks to whom every "human explorer will be able to carry his investigations much further," and swore by the power of the imagination, for it showed "what can be." He also staked out a grand objective, namely "the future resolution of these two states, dream and reality, which are seemingly so contradictory," and thus to enable a new, higher reality—surreality—for which he offered a dictionary definition: "Surrealism is based on the belief in the superior reality of certain

Philippe Halsman, photo from the series
Dalí's Mustache, 1954

forms of previously neglected associations, in the omnipotence of dream, in the disinterested play of thought. It tends to ruin once and for all all other psychic mechanisms and to substitute itself for them in solving all the principal problems of life."

The manifesto's guiding principle was a deep reverence for fantasy and imagination, the unfettered existence of childhood, and "freedom of thought." Its author was also convinced that, by integrating forgotten and suppressed ideas and emotions into everyday life, people would discover new ways of seeing and a new consciousness. It would be a state of sexual liberation, free of all bourgeois conventions, morals, and norms, and thus also without "oppression based on the family, religion, and the fatherland," as Breton wrote elsewhere. Breton, who had worked as a doctor at psychiatric institutions before devoting himself to poetry and writing, later announced a "triple objective": to "transform the world, change life, remake from scratch human understanding." But none of this was possible without the wonderful: "The wonderful is always beautiful, it doesn't matter what wonderful is beautiful, there is nothing more beautiful than the wonderful."

The Surrealists considered themselves neither geniuses nor talented artists. They wanted to help the world become surreal, far from any familiar aesthetics. Initially, they did so mainly through their poetry, which was often the result of chance, spontaneity, or "automatic writing." Then came painting, which depicted the artist's inner mind in previously unseen ways, followed by art made using everyday items or natural objects that were taken out of their original context to create confusing, mysterious, or even humorous associations. And finally, the Surrealists used the younger media of film and photography to create works in which human figures, the sexes, and physical space underwent what often felt like arbitrary

metamorphoses, in which dream blended with reality and even the laws of nature seemed to be suspended. Their works could be unsettling or shocking, they could arouse fears and desires, and they were a constant assault on logic and reason.

But might politics somehow help the Surrealist cause? The group's discussions on the issue in 1925 provided no clear answer. If anything, they marked the beginning of persistent conflict among the avant-garde and led not only to personal disputes within the group but also caused individual members to adopt ever-changing, ambivalent positions. The Surrealists took a stand against war, colonialism, and social hierarchies; they were against all that was bourgeois and in favor of social revolution—and thus they found themselves sharing much in common with the Communist Party. Much debate was centered on whether mankind could be liberated only after the transformation of the social and economic status quo. Breton eventually proclaimed himself a supporter of Marxism and the Soviet revolution. In 1927, he joined the French Communist Party along with the writer Louis Aragon and several other Surrealists, but he refused to compromise with the communists on cultural matters. However, it soon became clear that the Surrealists were more interested in supporting communism than the Party was in accepting Surrealism. In 1930, Breton published the *Second Surrealist Manifesto* with the aim of stabilizing the Surrealist movement, but in fact it revealed the group's split personality: although it reaffirmed the contents of the first manifesto, it additionally emphasized the importance of alchemy and occultism as well as social and political revolution.

At the time, Dalí was one of the Surrealist group's newest members. He still believed in Marxism, but he would soon learn what the communists thought of him. In 1931 the Surrealists' official

magazine, *Le Surréalisme au Service de la Révolution,* published one of his texts to which he had given the romantic-sounding title *Reverie.*

The essay opens with Dalí's description of lying down on the couch for an afternoon rest and to contemplate Arnold Böcklin's painting *Isle of the Dead.* In the darkened room, Dalí first starts playing with bread crumbs, then with his member. Soon he finds himself overwhelmed by a "reverie" that continues over several days, occasionally interrupted by his daily routine. In these daydreams, Dalí explores the places of his childhood. There are cypresses and Böcklinian clouds and it smells of animal excrement, which adds to Dalí's sweet and dreamlike state. He dreams of a house and a barn. As he watches this scenery, he rolls some breadcrumbs into a ball that he sticks in his nose, but later this falls out, rolls onto the couch, and eventually lands under his buttocks. After retrieving it, he sticks it back in his nose. Again, he plays with himself. Soon he is daydreaming again. A woman appears who, out of love for Dalí, is willing to give him her eleven-year-old daughter Dulita. He now imagines "sodomizing" Dulita and describes the days of preparation in precise detail. An aging prostitute is called upon to help prepare Dulita's "initiation." For three days, he places ears of corn on Dulita's chair. Eventually, she is led to the barn, where she has to lie on rotten straw and animal droppings. It is All Souls' Day. But just when Dalí is about to throw himself on the girl in order to take her from behind, she is transformed into "the woman I love"—meaning Gala. The essay ends with Dalí's comment that he is "analyzing [the daydream] objectively" by writing it down "with the greatest scrupulousness."

Dalí's *Reverie* was provocative and shocking. It was an assault on both reason and bourgeois morals, and was surreal through

and through. It was also roundly condemned by the communists, who immediately summoned several Surrealist members of the French Communist Party to their headquarters, where a party official warned them to abandon their Surrealist ways. He had his own particular interpretation of *Reverie*, and he told them: "You only want to complicate the exceedingly simple and healthy relations between men and women." Other party members found the text simply "pornographic." Louis Aragon was even ordered to write an official statement condemning the text. But Breton was opposed. In fact, he was convinced that one day "it will be a credit to the Surrealists to have violated a prohibition which in spirit is so remarkably petit-bourgeois."

For Dalí, politics was now a closed chapter. Instead, he believed even more strongly in his mission. Looking back later, he said, "Marxism to me was no more important than a fart, except that a fart relieves me and inspires me. Politics seemed to me a cancer on the body poetic [...]. Having no part of it seemed to me the only effective method of action and self-defense. The only honest way to deal with the poesy one carried within oneself like a rare and delicate flame. The defense of my own intimate interests seemed to me as urgent, proper, and fundamental as that of the proletariat. Besides, what would the victory of the proletariat mean if artists did not provide the elements of a style of life based on freedom and quality? A world of nameless grains of sand!"

In 1933, Breton, Paul Éluard, and Crevel were expelled from the French Communist Party. They had been accused of attacking Soviet culture because they had written critically about Russian film. Nevertheless, they remained convinced of the communist cause.

For Dalí, however, Lenin (and Hitler) had become figures that nourished his dreamlike observations, his images born of delusion

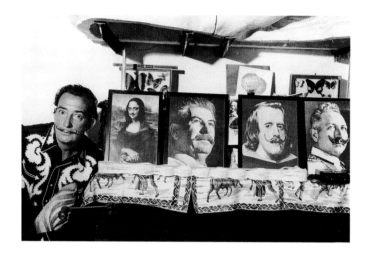

and paranoia. During one such moment of reflection unfettered by logic and reason, Dalí realized that his father—who in 1929 had repudiated his son because of his relationship with Gala, who at the time was still married to the poet Paul Éluard—was the reason for his earlier "devotion to Stalin." As he explained it: "By a sort of projection I had recomposed the impulses of my unconscious around the image of the Little Father of the Peoples. From this experience I understood the hold that the 'Man of Steel' had over his contemporaries through the Oedipus complex. He appeared as the fatal father whose power one must endure in order to grow in one's own eyes and whom one venerated in his worst excesses because he embodied fatality."

By extension, the figure of Lenin with an almost infinitely long buttock in Dalí's 1933 painting *The Enigma of Wilhelm Tell* was also

*Unknown, Dalí with the portraits
of famous moustaches in his studio,
ca. 1963*

meant to represent his father. The painting was an expression of his triumph over the authority of both his father and Lenin. But Dalí's struggle against communism had just begun.

In a 1939 letter to Luis Buñuel in America, Dalí clearly expressed his view of Marxism: "It would be terrible for you to give up political Marxism but to continue to think like a Marxist in other areas, since Marxism prevents us from comprehending even a little of the phenomenon of our era—a young, inherently wonderful science such as 'morphology,' the conjunction of morphology and psychoanalysis." In another letter to Buñuel, he explained, "Marxism is shit, the last relict of Christian shit—I respect Catholicism; it is sound."

Buñuel was not the only person whom Dalí admonished. In 1951, when Dalí gave a lecture in Madrid on the subject of *Picasso and I,* he first praised Franco, who was the reason Picasso refused to set foot in Spain. Then he praised Picasso, but made sure to point out that although Picasso was a communist he himself was not. Then he read a telegram that he had just sent to Picasso: "The spirituality of Spain today is the maximum opponent of Russian materialism. You know that in Russia they're purging even music for political reasons. Here we believe in the total and Catholic liberty of the human soul. You know, therefore, that despite your current Communism we consider your anarchic genius an inseparable heritage of our spiritual empire, and your work a triumph of Spanish painting. God protect you." Dalí never gave up hope for Russia, though. As an avowed monarchist, he was convinced that it would one day be saved by the monarchy.

Dalí had turned his back on communism, but its founding fathers remained a part of his fantastical world of the imagination, and found application in several of his projects. In 1949, Dalí

began working on an idea for a film called *The Flesh Wheelbarrow*. In one of his favorites scenes, King Ludwig II of Bavaria, Friedrich Nietzsche, Sigmund Freud, and Karl Marx were to appear together and proclaim their ideas in song. It was going to be a kind of liturgical antiphon, set to the music of Georges Bizet. Years later, Dalí was still working on the script, with Anna Magnani in the lead and himself in the role of a house painter. The script also called for a hundred swans and a hundred men dressed as Karl Marx. It was never realized.

Shortly after the death of Stalin in 1953, Dalí came up with his own theory as to why communism was now doomed to failure. After observing the facial hair of communism's founding fathers, he concluded that "the evolution of Marxism reveals an inexorable process of capillary decadence. Marx had a beard of biblical luxuriance; Engels's was more neatly trimmed; Lenin wore a moustache and a goatee; Stalin only wore a moustache, and now along comes Malenkov with a face as clean-shaven as the moon. 'Happiness makes the hair grow,' as we Catalans say. The capillary tristesse of Communism is another omen of its inevitable decline."

A year later, sitting in the studio of the photographer Philippe Halsman while working on their joint project *Dalí's Mustache*, he decided to realize this "capillary" theory in visual form. When Halsman asked, "What do you think of communist growth during the last hundred years?" Dalí answered, "From the point of view of hair on the face, there has been a steady decline." In the final book, this question and answer are printed alongside a photograph of Dalí with the longest moustache he ever wore. Hanging from his whiskers are five little cardboard medallions depicting the five bearded representatives of communism. **[fig. p. 30]** Actually, Dalí wanted to add a portrait of Khrushchev as well, but Halsman was

opposed to this. Dalí later asked proudly, "Who [else] could have attached to his unique moustache the entire past and future history of Marxism?"

In 1956, during the waning days of the McCarthy era in America, when communists and communist sympathizers were subjected to immense persecution, artist and Dalí biographer Fleur Cowles traveled to Port Lligat in order to visit Dalí. When she entered his studio, she stared in amazement: in his studio was a large photograph of Stalin. Dalí, who regularly spent his winters in America, explained with a grin: "How else can you prove today that you're not a Communist?"

Here Comes the Dalí Moustache

I have to disguise myself as a jester
and cannot forgo my superb moustache
in order to show the world: Here is Dalí.
S.D.

When Dalí first visited New York in 1934, he considered it his main task to spread the word about Surrealism in the New World. But he would later call the trip his "American campaign," since in actuality he was far more interested in spreading the word about Dalí. He once said, "I am not a Surrealist, I am Surrealism," to which we might add: with every whisker of his being.

In 1936, Dalí undertook another trip to New York. In a letter to André Breton, the spokesman of the Surrealist movement, he described a scene of "uninterrupted excitement." Surrealism, he wrote, was "all the rage." No wonder, then, that in December of that year the cover of *Time* magazine featured a photograph of Dalí that Man Ray had taken back in 1929. **[fig. p. 10]** Inside, readers learned that "Surrealism would never have attracted its present attention in the United States were it not for a handsome thirty-two-year-old Catalan with a soft voice and clipped cinema actor's moustache, Salvador Dalí."

Combined with a solo exhibition at the Julien Levy Gallery and his participation in the group exhibition *Fantastic Art, Dada, Surrealism* at New York's Museum of Modern Art (where he showed, among other works, the already famous *The Persistence of Memory*),

New York Times,
Salvador Dalí, 1935

the *Time* magazine article helped make the European with the actor's moustache famous in America. People even stopped him on the street to get his autograph. Thus was born a great love: America loved Dalí and Dalí loved America in return, even if—to his great disappointment—the country had no monarchic tradition.

In 1937, Dalí again boarded a ship for America. This time, however, he was headed for Hollywood, convinced that "Surrealism takes to it like honey on explosive giraffes." In Los Angeles, the star artist with the Menjou moustache met Groucho Marx—the comedian with his own trademark moustache as well as Groucho's brother Harpo and the mustachioed Walt Disney, but not Clark Gable, whom Dalí did not consider a Surrealist even though he also wore a Menjou moustache.

Although Dalí had hoped to make a film with Harpo Marx, whom he considered an even greater Surrealist than Groucho, the project never took off. Instead, he ended up making a short movie with Walt Disney. Begun in 1946 but not finished until after his death, *Destino* featured (among other things) two giant turtles carrying strangely distorted heads on their shells, one of which sports a very Dalínian moustache.

That same year, Gertrude Stein published *Everybody's Auto-biography*, in which she not only presented several very perceptive observations about Dalí, but also had unique praise for his facial hair, calling it "the most beautiful moustache of any European." But she never described it as a Hollywood movie actor's moustache. Instead, she placed its origins in the world of Islam: "that moustache is Saracen there is no doubt about that."

Dalí's next trip to America was in early 1939. Shortly before his departure, an important meeting took place between Dalí and André Breton. Dalí's skepticism towards the Surrealist group

had been constantly growing, but instead of resolving their differences, Dalí's break with the Surrealists was now complete. Did Dalí once again test the limits of freedom within the Surrealist group and consciously provoke Breton? Or did Breton demonstrate his understanding of freedom by criticizing the fact that Dalí had explained the worldwide unrest in racial terms and, as a solution, proposed making the dark races the slaves of the white race? Breton was convinced that Dalí could no longer be taken seriously in a circle of independent spirits, that he and his painting had little influence on the art world, and that his paranoiac-critical method was no more than a party game, a crossword puzzle. And so Dalí's longtime friend, whom Dalí had once considered a second father, definitively expelled him from the Surrealist family.

A year later, Breton, appalled at Dalí's commercial success in America, created an anagram from the name Salvador Dalí—"Avida Dollars." But the avowedly dollar-obsessed Dalí enthusiastically embraced the name and even used it as his signature. Years later, he still thanked Breton for inventing the moniker.

That March, Dalí designed a window display for the New York department store Bonwit Teller, which he destroyed (along with the plate glass window) when the store's management changed his work without his permission. The press immediately praised him for defending the "independence of American art." Dalí's fame continued to grow.

In May 1939, Dalí signed a contract to design a pavilion for the New York World's Fair. He immediately set to work, ordering the construction of an oversized reclining female figure whose spread legs acted as a gateway through which visitors would enter the exposition. He envisioned a giant aquarium with mermaids milking underwater cows and playing a piano in the shape of a reclining

woman. Besides Dalí's paintings, the exhibition would also feature a sculpture inspired by Botticelli's Venus with a fish head in place of a human one. His vision was of a never-before-seen Surrealist *Gesamtkunstwerk*. But then he was forbidden from placing a fish head on the Venus statue. Furious, Dalí departed before the opening of the World's Fair. Before leaving the country, however, he wrote a manifesto entitled *Declaration of the Independence of the Imagination and the Rights of Man to His Own Madness*, which he printed up in flyer form and dropped over New York City. Among other things, the manifesto proclaimed, "Artists and poets of America! [...] Only the violence and duration of your hardened dream can resist the hideous mechanical civilization that is your enemy, that is also the enemy of the 'pleasure-principle' of all men. It is a man's right to love women with the ecstatic heads of fish. [...] New York! You who are like the very stalk of the air, the half cut flower of heaven! You, mad as the moon, New York! I see you won by the Surrealist 'Paranoia-Kinesis,' you may well be proud, I go and I arrive, I love you with all my heart."

While Dalí was working on the World's Fair, something strange was happening on his face: although he continued to trim his Menjou moustache, on several occasions he grew a three-day beard. **[fig. p. 45]** It was a portent of the fundamental transformation that his facial hair was about to undergo.

Back in Europe, Gala and Dalí responded to the increasingly turbulent situation preceding World War II by repeatedly changing residences. They briefly lived in the Pyrenees, then traveled to Paris, and subsequently spent several months in a small town near Bordeaux. Danger and chaos threatened the land. Soon, America would become a place of refuge for Dalí and for many other Surrealist artists: Breton and Max Ernst, the latter of whom

had been interned in southern France in 1939, fled for America as well.

Dalí and Gala left France in June 1940, two days before German troops occupied the town of Hendaye on the Spanish border. By now Dalí's moustache had grown a bit fuller. They no longer felt at home in Europe, and America would be their home for the next eight years. Gala traveled to Lisbon to organize their journey, while Dalí went to see his father in Figueres. Than he visited Port Lligat, where he learned that his house had been plundered and partially destroyed during the Spanish Civil War. Dalí and Gala reunited in Lisbon and together boarded a ship to the New World. In *The Unspeakable Confessions of Salvador Dalí*, Dalí later wrote, "Dalí did not wait to find out, and the *Exemption* carried me off toward freedom. I was never so happy for my egotism that kept

Eric Schaal, *Salvador Dalí*
(with three-day beard), 1939

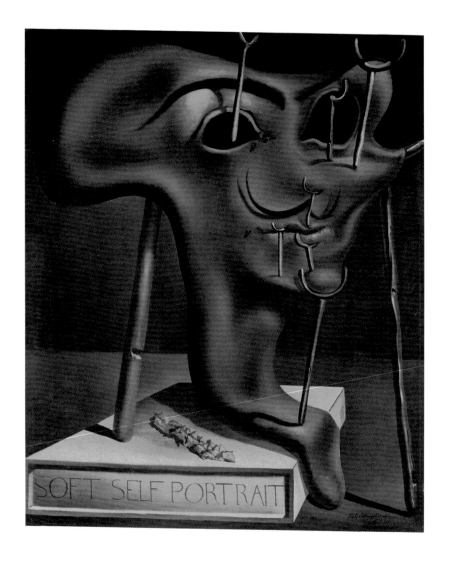

Salvador Dalí, *Soft Self-Portrait*
with Grilled Bacon, 1941

me from looking back and avoided my being turned into a statue of the salt of pity and compassion. Unhappy the poor of mind who let themselves be tied up by noble feelings! I was abandoning the old cracked face of a senile, lazy Europe, purulent with its contradictions, gnawed by skepticism, drunk with materialism."

On August 16, 1940, Dalí and Gala arrived in New York. As he shed a part of his old self, he was ready for something new, and it had an immediate effect on his facial hair: his moustache grew thicker and its tips longer, until he could twirl their ends. **[fig. p. 49]** These were the tender beginnings of the Dalí moustache that would soon become his trademark.

In 1941, Dalí painted a picture that he christened *Soft Self-Portrait with Grilled Bacon*. **[fig. p. 46]** Although in real life his moustache was still "properly" positioned in a slightly undulating line beneath his nose, the tips of the moustache in this self-portrait rose to entirely different heights. It is a strange thing: All the parts of the face (which is placed on a pedestal) are as soft as dough and need to be held up by crutches. But the moustache needs no support. Crutches had been a fetish for Dalí since childhood. They helped to "maintain my weak notion of reality," but they could also symbolize authority, magic, and much more. This moustache, which without beard wax would have melted like viscous dough across Dalí's face, is the only part of the body with enough strength of form to guarantee its stability.

Dalí later said of the painting that it reflected his personal situation in America at the time. Dalí, who strongly yearned to find his own uniquely individual identity far from the ghost of his dead brother that followed him wherever he went, was constantly in the process of forming himself. Elsewhere, he said that his objective was "constantly to prove to everybody that the real Salvador is not

the other, the dead brother." This self-portrait was also a picture of the future, because it showed the Dalínian moustache with its long skyward-pointing hairs that still did not exist when he was painting the picture in 1941, but that he had dreamt of since his youth. **[fig. p. 23]**

In 1941, after completing *Soft Self-Portrait with Grilled Bacon*, Dalí was visited by a journalist from the *Washington Times-Herald*. The reporter noted that Dalí's moustache was much shorter than in the self-portrait. Dalí initially responded that he had cut back his moustache that very morning. Then he said that he had purchased a moustache like the one in the painting and that he would wear it from then on so that people would recognize him. The journalist, who found it all a bit incomprehensible, didn't ask any more questions about it. Dalí had apparently realized that, if he wanted to become Dalí, nothing would help him more than an ultra-individual moustache. And as his moustache grew, so too did his fantasy—of this he was sure. With every centimeter of moustache, he grew more famous until he was as popular as his paintings. In the process, Dalí grew into the Dalí he wanted to be.

Philippe Halsman,
Salvador Dalí, 1942

A Paranoiac-Critical View:
Moustache Metamorphoses in Exile

Life on Earth would be practically impossible
if there were two or three hundred Dalís,
but never fear – it will never happen!
S.D.

When Dalí left Bordeaux in September 1939, his Menjou moustache resembled a large bird that only looks small because it is flying high up in the sky. But by the time German troops were marching across France and reached the port city of Hendaye, Dalí's moustache had grown fuller. The bird's wings felt larger, as if it were flying just a few feet overhead. The bird took flight in both senses of the word: flying and fleeing all at once.

In Dalí's American exile, his moustache came alive, like a snake inching towards its goal by its undulating movements. And where there is a snake, temptation is not far behind. Temptation is followed by love, for cupid's arrow has struck the snake dead-center, causing its ends to rear up to the sky. Its movement is all the clearer when the ground beneath appears as a straight line. Then, in 1944, Dalí began working on a painting of a basket with a piece of bread. When he finished it the following year, he called it *Basket of Bread – Rather Death Than Shame*. The tips of Dalí's moustache turned a little further upwards.

Carl van Vechten, *Portrait of
Salvador Dalí with carved black head
adjacent to his face*, 1939

HIEROGLYPHIC INTERPRETATION

THE PSYCHOANALYTIC ANALYSIS OF THE MUSTACHE OF SALVADOR DALI.

Mustache? Mustache? Mustache?

In Paris I always usted to carry a pretty cigarette case with several false mustaches of the Adolphe Menjou type, and I would offer to my friends mustaches, mustaches, mustaches.

The reason for my mustache is that I do not smoke, it establishes the nervous ceremony of the gestures of the hand in a state of reflection.

Departure from Bordeaux.

German troops arrive at the international port of Hendaye.

1941-44.

I paint "The basket of bread".

The double victory came two months after the bifurcation, on crutches, of my mustache.

Flight.

Temptation.

Love.

Broken Wings.

DO YOU SUFFER "PERIODIC" INTELLECTUAL MISERY?

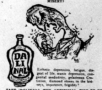

DALINAL

Esthetic depression, fatigue, disgust of life, manic depression, congenital mediocrity, gelatinous Cretinism, diamond stones in the kidneys, impotence, frigidity?

TAKE "DALINAL", THE ARTIFICIAL FIRE OF THE SPIRIT WHICH WILL STIMULATE YOU AGAIN.

Headlines of American Press

Natures imitates daliesc effects

Dali sketches woman of **2.075**

Atomic era will be like Dali dreams

Life in occupied Riech is like Dalis paintngs

Salvador Dalí, "Hieroglyphic
Interpretation"
in: *Dalí News*, p. 4, 1945

Or perhaps the arrow split the snake in half, so that two snake bodies are lying on top of one another like the upper and lower lips of a mouth, that indispensable accessory of love. In this division it also resembles the broken wings of a bird. Around this time, Dalí's moustache was finally long enough so that he could split its ends, as captured a few years later in a photograph by Willy Rizzo. **[fig. p. 64]** Splitting the moustache was also an act of doubling, like the double victory of the Americans, who in 1945 defeated both Germany and Japan. And while all this was happening, a key turned into two ants. Maybe it was like this; maybe it was all completely different.

This description is but a vague attempt at explaining how Dalí viewed his moustache's metamorphosis in exile, far beyond the rational and logical. It is based on his article "Hieroglyphic Interpretation: The Psychoanalytic Analysis of the Mustache of Salvador Dalí," published in November 1945 in the first issue of his own newspaper, *Dalí News – Monarch of the Dailies.* **[fig. p. 52]** The article offered a highly individual, visual interpretation of his moustache metamorphoses that was comprehensible for probably just one person: Dalí himself. In the left-hand column is a description of the various political and artistic stations of his years in exile, the middle column shows the relevant metamorphoses of his moustache, and on the right are the pictures that Dalí associated with each particular moustache.

The article was also an illustration of the paranoiac-critical method that he had developed in 1929 and that had influenced his view of the world since childhood. When he looked at "the foaming waves in the sky," he would see "breasts, buttocks, heads, horses, elephants," or also "monstrous couplings, titanic struggles, tumults and gatherings of crowds." Apparently, even at this early

age he was already heeding the advice of Leonardo da Vinci, an artist to whom Dalí would later compare himself. Da Vinci told his students, "When you look at a wall spotted with stains, or with a mixture of stones, if you have to devise some scene, you may discover a resemblance to various landscapes, beautified with mountains, rivers, rocks, trees, plains, wide valleys and hills in varied arrangement; or again you may see battles and figures in action; or strange faces and costumes and an endless variety of objects, which you could reduce to complete and well-drawn forms." At times, the young Dalí truly found it difficult to differentiate between dream, daydream, delusion, and reality. For this reason, he later called his method paranoiac, because it clearly promoted the sort of delusions and hallucinations that characterize the psychiatric illness then known as paranoia. Consequently, during his first visit to America in 1934 Dalí declared, "The only difference between a madman and me is that I am not mad."

While Dalí was developing his method, he regularly corresponded with the French psychoanalyst Jacques Lacan, whose writings he saw as confirmation of his method. In addition, he had long been a fan of Sigmund Freud. After meeting Dalí in the fall of 1933, Julian Green reported that Dalí spoke of Freud "like a Christian talks about the New Testament." It is thus no wonder that Dalí's title for the article on his method, published in 1945 in *Dalí News*, was "Psychoanalytic Analysis." After all, he saw his method as continuing in the tradition of psychoanalysis.

Dalí had described his paranoiac-critical method, which he hoped would influence his art, many years earlier, in 1930: "A spontaneous method of irrational knowledge based on the interpretative-critical association of delirious phenomena." And: "It is by a distinctly paranoiac process that it has been possible to obtain

a double image: in other words, a representation of an object that is also, without the slightest pictorial or anatomical modification, the representation of another entirely different object, this one being equally devoid of any deformation or abnormality disclosing some adjustment."

Dalí used his paranoiac-critical method to analyze not only paintings, but also objects and many other phenomena in the real world. His aim was not to distract from truth and reality, but to question the general concept of reality in a world defined by reason.

In *The Unspeakable Confessions of Salvador Dali*, Dali prophesied: "It is time for us, in the history of thought, to see that the real as given to us by rational science is not all of the real. The world of logical and allegedly experimental reason, as nineteenth-century science bequeathed it to us, is in immense disrepute. The very method of knowledge is suspect. The equation has been formulated by skipping over the unknowns and assuming a part of the problem to have been solved. In the end, it will finally be officially recognized that reality as we have baptized it is a greater illusion than the dream world. Following through on my thought, I would say that the dream we speak of exists as such only because our minds are in suspended animation; the real is an epiphenomenon of thought, a result of non-thought, a phenomenon of amnesia. The true real is within us and we project it when we systematically exploit our paranoia, which is a response and action due to the pressure—or depression—of the cosmic void. I believe my paranoia is an expression of the absolute structure, the proof of its immanence. My genius consists of being in direct contact with the cosmic soul."

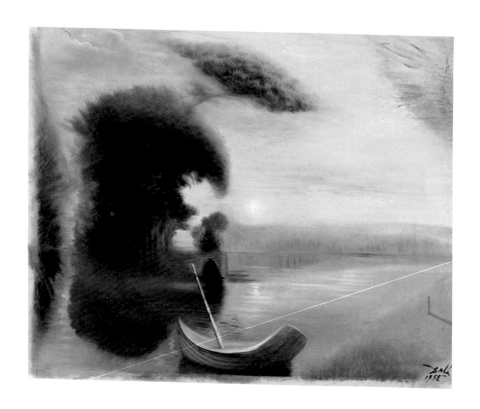

Metamorphosis of Hitler's Face into a
Moonlit Landscape with Accompaniment –
Toselli Serenade, 1958
(from the Robert Descharnes Archives)

Hitler's Tragical Constant

In reality was Hitler a masochist
who longed for the abyss.
S.D.

Just a few months after Dalí's death in January 1989, the Staats-galerie Stuttgart showed a large Dalí retrospective that was subse-quently exhibited at the Kunsthaus Zürich. The exhibition included a painting from 1958 entitled *Metamorphosis of Hitler's Face into a Moonlit Landscape with Accompaniment – Toselli Serenade*. [fig. p. 56] According to the exhibition catalogue, it had originally been made for a film by director Robert Descharnes, a sometime secretary of Dalí's, and was meant to illustrate the paranoiac-critical method. However, the film was never completed and thus never shown. The catalogue text goes on to explain that Dalí had made the painting on the basis of a portrait photograph of Hitler—or more specifically, it was based on Hitler's nose and moustache. This becomes clear if we rotate the painting 90 degrees counterclockwise. Flipped upright like this, the distant shore becomes Hitler's nose, surrounded by the deep lines of the face, and the dark island is Hitler's moustache.

It is a strange painting: A still body of water, a lonely barge lying on the shore. An oar, held upright in its middle as if by a ghostly hand, points towards a small island. Cold moonlight illuminates this nighttime scene, and a heavy darkness seems to emanate from

the island with its gloomy, tall trees reflected in the water. A small boathouse on the island's right-hand shore tells us that the barge is not meant for excursions, but serves solely as a means for reaching the dark island. It is a landscape bathed not in nocturnal magic, but in the darkest mystery and leaden horror. It is a landscape devoid of people, shrouded in somber tones devoid of red, blue, or yellow.

It is not the first time that Dalí used Hitler in his art. He first began to intensively explore the "Hitler phenomenon" in 1933 by "situating Hitler from the Surrealist point of view." He saw it as an artistic challenge that all Surrealists should engage in. However, in February 1934 André Breton and other members of the Surrealist group, including Max Ernst and Meret Oppenheim, penned a resolution demanding Dalí's expulsion. They charged Dalí with being "guilty on several occasions of counter-revolutionary actions involving the glorification of Hitlerian fascism," and demanded that he be "excluded from Surrealism as a fascist element and combated by all available means." At the same time, Dalí still had many supporters among the Surrealists, including Hans Arp, Man Ray, and Alberto Giacometti, who refused to sign this resolution. How had it come to this?

For Dalí, Hitler (and, incidentally, Lenin as well) was initially an ideal subject for his paranoiac-critical analyses. But the results of his analyses were not just provocative—some people found them downright intolerable. And yet, Dalí's insights sprang not from logic and reason, but from his dreams and from states of delirium and delusion. For instance, he repeatedly saw Hitler as a woman, and stated later, "I was fascinated by Hitler's soft, fleshy back, always so tightly encased in his uniform. Every time I started painting the leather strap that ran from his belt across the opposite shoulder, the softness of the Hitlerian flesh squeezed into the military tunic brought me to a state of ecstasy that was simultaneously gustatory,

milky, nutritive, and Wagnerian, and made my heart beat violently, a very rare emotion I don't have even when I'm making love. Hitler's chubby flesh, which I imagined to be like the most opulent feminine flesh with the whitest skin, fascinated me."

He also wrote that, "conscious nonetheless of the psycho-pathological nature of such transports, I was thrilled to whisper into my own ear: 'Yes, this time I believe I'm on the verge of true madness!'" For, as he later said, he saw Hitler as a "great masochist who would unleash a world war solely for the pleasure of losing and burying himself beneath the rubble of an empire." Dalí repeatedly defended himself to the Surrealists, arguing that his "Hitler-inspired vertigo was apolitical" and not in the least glorifying, and that it was "tinged with [...] with morbid humor."

A few days after Breton and the others wrote their resolution against Dalí, Breton invited him to his studio in order to discuss his future. Breton called the meeting a "special session," but for Dalí it was "the trial." In the end, even more accusations were leveled against him. One of the most serious was that he was not on the side of the proletariat, and that his 1933 painting *The Enigma of Wilhelm Tell* depicted Lenin with a bare behind—and, what is more, with one immensely long buttock. The leftist Surrealists called it "defamatory." Dalí appeared at the meeting wearing seven wool sweaters and a thick camel's-hair coat, with a thermometer in his mouth. He was ill—or at least he thought he was—and was playing with it. Then began a surreal Dalí performance: He took off his coat, took off his suit jacket, took off one of the seven sweaters, took off his shoes. Then he put on the jacket and coat again. Over time, he took off more and more sweaters like this. Soon, people were even laughing. In between this performance, Breton leveled angry accusations at him and Dalí offered his defense.

Later, Dalí described how he made his case that day: "I highmindedly stated that to me the dream remained the great vocabulary of Surrealism and delirium the most magnificent means of poetic expression. I had painted both Lenin and Hitler on the basis of dreams. Lenin's anamorphic buttock was not insulting, but the very proof of my fidelity to Surrealism. I was a total Surrealist that no censorship or logic would ever stop. No morality, no fear, no cataclysm dictated their law to me. When you are a Surrealist, you have to be consistent about it. All taboos are forbidden, or else a list has to be made of those to be observed, and let Breton formally state that the kingdom of Surrealist poetry is nothing but a little domain used for the house arrest of those convicted felons placed under surveillance by the vice squad or the Communist Party."

Dalí closed his defense by arguing that of course he was not a Nazi, "because if Hitler were ever to conquer Europe, he would do away with hysterics of my kind."

In the end Dalí won the day and avoided expulsion. But over the years his ambiguous and consciously provocative views and his artistic examination of Hitler would repeatedly earn him harsh criticism, and not just from other Surrealists.

On one occasion, however, Dalí attempted to refute Hitler. A friend, the artist Lord Berners, had asked Dalí to sign a copy of Dalí's 1935 book *The Conquest of the Irrational*, in which he had sharply criticized abstract art. Lord Berners intended to present the signed copy to Hitler at the Nuremberg Party Congress. Lord Berners claimed that Hitler saw in Dalí's works a "Bolshevik and Wagnerian atmosphere," especially in the way he painted cypresses. But instead of signing the book for Hitler, the self-professed cross specialist used two strokes to draw a simple "stoic

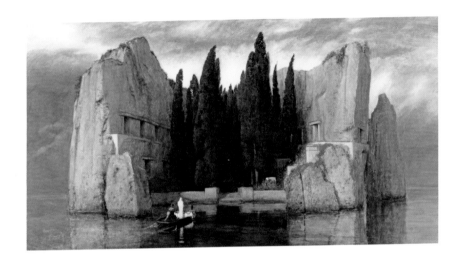

Arnold Böcklin,
Isle of the Dead , 1883

cross [...] magically and in a condensed fashion, the fifth essence of the total contrary of the swastika."

Dalí believed that Hitler "must have antennae charged with magic, stuffed with horoscopes," and was convinced that the cross was effective as a magical counterforce. Although the book never reached Hitler, Dalí was sure that the Führer would surely "have been frightened for quite a long time, till his death in the bunker at Berlin, because of my augury."

But Dalí did not escape the old accusations leveled against him. As late as in 1960, a group of twenty-five Surrealists, including André Breton, tried to exclude Dalí from the International Surrealist Exhibition in New York. Their reasoning was that "more than ever do we see in this man, Hitler's former apologist, [a] fascist painter." As supposed proof for his ideological tendencies, they called Dalí, who had returned to fascist Spain in 1948, an "avowed racist, [a] friend of Franco."

They were probably not familiar with *Metamorphosis of Hitler's Face*. **[fig. p. 56]** Although the painting was not based on logic and reason, it is reminiscent of the work of another painter: Arnold Böcklin's *Isle of the Dead*, of which there exist five versions made between 1880 and 1886 that differ only in some minor details. **[fig. p. 61]** All the versions show an island shrouded in the deep blue of nightfall, with a dark cluster of trees at the island's center. They are cypresses, which since Antiquity have been considered symbols of death, and they are surrounded by a mighty rock with tombs hewn into its sheer face. Nearby, a barge is carrying a coffin across the water, the ferryman accompanied by a figure shrouded in white. The paintings' dark and mystical mood resonated especially with the German-speaking, culturally pessimistic, world-weary bourgeoisie of the fin de siècle, who saw the island as a place of yearning. But

the paintings also fascinated more than a few Surrealists, including Dalí, who saw Böcklin as more of a Surrealist than Matisse. Not only did he write an essay about Böcklin and *Isle of the Dead*, but in 1932 he even painted his own version of *Isle of the Dead*, which he called *The True Painting of the "Isle of the Dead" by Arnold Böcklin at the Hour of the Angelus.*

Someone else who was fascinated by Böcklin's *Isle of the Dead* was Hitler. In fact, he acquired the third version **[fig. p. 61]** of the painting and hung it in the music room of the Reich Chancellery, which often resounded with the music of Wagner, whose compositions had long been associated with the visual world of Böcklin.

Unlike Böcklin's painting, however, *Metamorphosis of Hitler's Face* does not depict a place of yearning or an Arcadian landscape in which death is stripped of its horrors. The isle of the dead that Dalí discovered in Hitler's face is the exact opposite: It is the terminus of all, a black hole of fear and hopelessness. There are no beings here, not even a ferryman of the dead. There is only Hitler's moustache—the island, home not to cypresses but to dark and gloomy vegetation. It is the focal point of this gray painting, which is a manifestation of the deepest horrors. Neither the moonlight sharply illuminating the distant shore nor Toselli's otherwise sweet sonata can change this impression. Quite the opposite, in fact. In his *Diary of a Genius*, Dalí wrote that his old friend from his youth, the poet Federico García Lorca, had been fascinated by Hitler's moustache, and had once said, "The moustache is the tragic constant in the face of man."

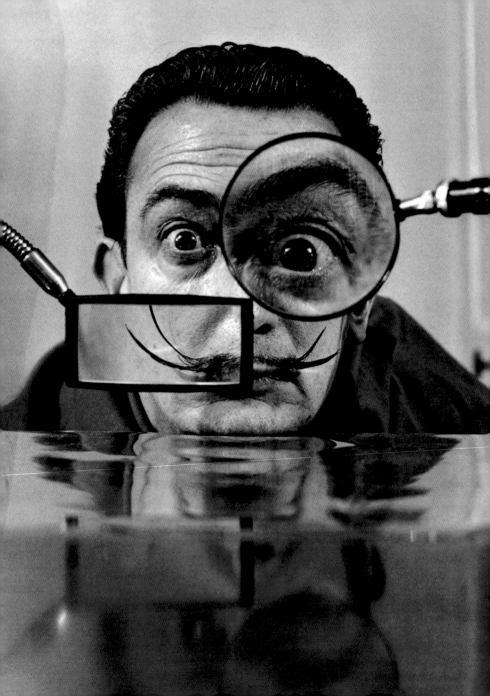

Mystical: The Moustache As Metaphysical Antenna

I am much more important
as a cosmic genius than as a painter.
S.D.

In 1948, Dalí and Gala left their American exile and returned to Spain, which since the end of the Spanish Civil War had been ruled by the dictator General Franco. Nevertheless, America would remain a second home for Dalí, and he and Gala regularly traveled to New York in November and returned to his beloved Catalonia in April. His time in Spain was interrupted only by frequent visits to Paris, where he always stayed at the Hotel Le Meurice.

Although Dalí had not painted much while in exile, he had still managed to become a highly interesting subject for the media. In the process, he laid the foundations for marketing himself in the future.

From now on, most of his creative work took place in the former fisherman's hut in Port Lligat that he and Gala had purchased in 1930, which they constantly expanded through new additions. Dalí was convinced that this was the only place where he could create truly great works. Here, he was surrounded not just by the landscape he loved, but also by a very special collection—his gallery of facial hair. **[fig. p. 36]**

As Dalí explained to his visitors, he collected pictures of famous men with beards. Hanging in his studio was an engraving of the

Willy Rizzo, *Salvador Dalí*, 1951

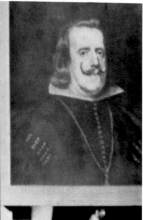

painter Diego Velázquez, whom he adored. Standing on a dresser in one of the house's countless rooms was an engraving showing Don Joseph de Marguerit, a seventeenth-century general whose mighty moustache with its upward-pointing tips makes him look like Dalí's ancient ancestor. **[fig. p. 36]**

Don Joseph de Marguerit had played an important role in driving the occupying Spanish forces from the town of Perpignan, which was of special significance to Dalí. In the early 1960s, he had declared that the town's train station was the mystical and cosmic center of the universe. Also decorating the dresser was a large framed photograph of the mustachioed Wilhelm II, whose whiskers may have been bushier than Dalí's but whose tips were twisted upwards in the proper manner. Right next to it was a reproduction of a portrait that Velázquez had painted of his patron, Spain's art-loving King Philip IV. A photograph taken in 1951 shows Dalí next to this reproduction. **[fig. p. 66]** The viewer cannot avoid comparing Dalí's

Unknown, *Dalí in front of a reproduction*
of Diego Velázquez' portrait of Philip IV,
ca. 1951

moustache with that of the ancient Spanish king and reaching the conclusion that, despite their similarities, in terms of facial hair the monarchist was superior to the monarch. And next to Philip was a photograph of Stalin, whose walrus moustache resembled that of the "depressive" (in Dalí's view) Friedrich Nietzsche. There was even room on the dresser for Philippe Halsman's 1954 photomontage of the Mona Lisa with Dalí's eyes, hands, and moustache. [fig. p. 36]

After his return from exile, Dalí declared that the main objective of his art would now be to transcend "the materialist and atheist elements of Surrealism." At the same time, his art was increasingly determined by mystical and religious themes. One possible influence was the ultra-Catholic atmosphere in Spain, which the newly Catholic Dalí—who admitted that he lacked the gift of faith—had been absorbing in his home country. But Dalí also said that modern science with its quantum mechanics and nuclear physics (especially the dropping of the atomic bomb on Hiroshima by the United States) had been the decisive impulse behind this new period in his art: "I want to see and understand the forces and hidden laws of things, obviously so as to master them. To penetrate to the heart of things, I know by intuitive genius that I have an exceptional means: mysticism, that is to say, a deeper intuition of what is immediate communication with the all, absolute vision by grace of truth, by grace of God."

During this time, he created paintings such as *The Madonna of Port Lligat* (1949), in which the Madonna was personified by none other than Gala. Dalí now worked with Renaissance-era techniques that gave his paintings a hyper-realistic look. But the general public was still more enthralled by his pictures of ants, fried eggs, and crutches from his Surrealist period. For his part, Dalí wanted to put Surrealism behind him. In 1952 he wrote in his diary: "My present

nuclear mysticism is merely the fruit, inspired by the Holy Ghost, of the demoniacal and Surrealist experiment of the first part of my life." A year earlier, he had published his *Mystical Manifesto*, which opened with the line: "The two most subversive things that can happen to an ex-Surrealist in 1951 are, first, to become a mystic, and second, to know how to draw."

All this time, the tips of Dalí's moustache grew longer and longer. It was no wonder that the moustache had now become another mystical instrument, a mystical antenna.

In December 1951, the French newspaper *Le Figaro* reported that Salvador Dalí had just "launched the fashion trend of the radar moustache" in London. The actual reason for his visit to London had been to introduce his new period of mystical painting. But where *Le Figaro* described Dalí's new paintings as "banal," the press considered Dalí's message regarding his moustache far more exciting. Indeed, it was a true sensation: Dalí had proclaimed that his moustache now acted like a radar that could receive vibrations from the atmosphere.

Where Dalí had previously found inspiration in the depths of his being with the help of his dreams and his paranoiac-critical method, he could now receive information from the atmosphere and channel it into his work. With this, Dalí's moustache took on an additional function, or even an additional dimension. He had sensed as early as the mid-1940s that his moustache was also an antenna, and although it was not yet ready to receive atmospheric vibrations, it did register events from daily life and so enabled him to perceive his surroundings more intensively and completely. As he explained in his 1948 book *50 Secrets of Magic Craftsmanship*: "It may also be suspected that for man, too, mustaches serve as antennae. This is all somewhat mysterious, but I no longer have

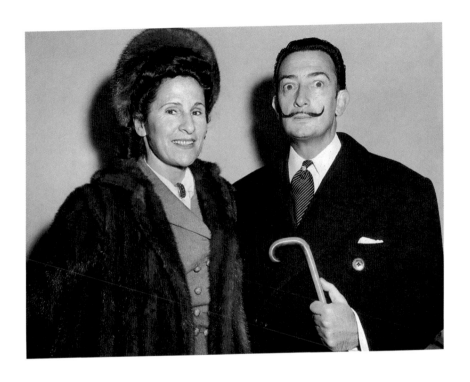

New York Times, *Spanish surrealist painter Salvador*
Dalí posing with his wife Gala on the ship "Vulcania"
upon arrival in New York City,
December 28, 1948

any doubt that with my mustaches I feel more alert, that I am more acutely conscious of everything that goes on and especially, of everything that moves around me. Because of their very length, with the tips pointed and curled up, the least change of light registers on the ends, immediately communicating itself to my eyes. Thus one day I became aware of the sun that was setting behind me, for I saw something like two tiny red cherries gleaming at the tips of my mustaches." So the idea of the moustache as an antenna was nothing new. Where whiskers initially acted as feelers like insect antennae, over time the moustache had expanded and refined its function.

Although Dalí's statements to the press in London were like many of his pronouncements, the truthfulness of which even he himself was not sure of, Dalí later admitted in an interview with the journalist Manuel del Arco that "today, however, and after careful consideration, I have reached the conclusion that the tips of the moustache are indeed antennae by which I receive a part of my surroundings. I have even sent a communique in this regard to the Congress of Hairstylists in Paris."

The "considerations" that led to this realization had also been nourished by the theories of the Neapolitan polymath Giovanni Battista della Porta, whose writings from the sixteenth and early seventeenth centuries Dalí had long been familiar with and had repeatedly referenced in his work. In the preface to his 1954 book *Dalí's Mustache*, Dalí explained that della Porta "considered mustaches and eyebrows as antennae susceptible of capturing creative inspirations, as do antennae of insects whose instinctive life is more refined." As proof, he presented the thick eyebrows of both Plato and Leonardo da Vinci (although without discussing their beards), before proclaiming, "But it was the 20th Century in

which the most sensational hairy phenomenon was to occur: that of Salvador Dalí's Mustache."

But something strange happened once Dalí began using his antenna moustache to receive inspiration from the cosmos. In the period after 1954, the year in which his moustache reached its maximum length, he repeatedly and noticeably cut the tips of his moustache back. **[fig. p. 114]** As he told Manuel del Arco, "When I am thinking, I let them grow. When I am done, I cut them back." He felt it necessary to trim the tips of his moustache whenever he had received too much metaphysical inspiration and the ideas had begun to accumulate without being implemented in art. Speaking in the same interview, he said, "I am currently painting, and have a storehouse of ideas for ten years. Far too many."

Dali's Mustache

BY

SALVADOR DALI
&
PHILIPPE HALSMAN

Absurd: Moustache Becomes Book!

Nobody realizes the commercial potential
of my moustache.
S.D.

In the spring of 1953, Salvador Dalí visited the photographer Philippe Halsman in New York. The two were old acquaintances who liked and trusted one another. The artist and the photographer had first met in 1941 during an exhibition of Dalí's works at the Julien Levy Gallery in New York. At the time, Halsman took a few pictures of Dalí and Gala, and Dalí immediately recognized Halsman's playful and experimental approach to photography. Thus began a friendship and artistic collaboration that would last nearly forty years.

Halsman was born into a Jewish family in Riga in 1906. He studied electrical engineering in Dresden before moving to Paris in 1931, where he came into contact with Surrealist circles and increasingly began to focus on his passion—photography. Initially he worked in advertising and for magazines, including *Vogue and Vu*, and shot portraits of artists such as Marc Chagall, André Gide, and Le Corbusier. In 1932, he opened his own studio in Paris, where he was soon joined by his wife Yvonne, whom he married in 1937. In October 1940, three months after Dalí had gone into exile in America, and with support from Albert Einstein, Halsman was able to leave for New York. His only pieces of luggage were his camera and a suitcase full of photographs.

Cover of the English edition of the book
Dalí's Mustache, 1954

But Surrealism and emigration to the New World were not the only things that Dalí and Halsman had in common. They also shared a similar sense of humor and irony and a similar psychological understanding of Man, which can be seen in one of their first collaborative efforts. Dalí had apparently told Halsman that he could remember being in his mother's womb. It was one of the stories included in the book *The Secret Life of Salvador Dalí* (1942), in which Dalí—playing fast and loose with the facts, and with a hefty dose of fantasy—turned his life into myth. Nevertheless, the story led to the idea of a photomontage in which Halsman placed an image of Dalí naked in the fetal position inside the picture of an egg.

Halsman went on to create many more portraits of Dalí. One of Dalí's favorites was made in 1942. **[fig. p. 49]** In the early 1950s, Dalí learned that the logarithmic spiral of rhinoceros horns, which he considered the most perfect of all curved forms, could also be found in the hairstyle of Vermeer's *The Lacemaker* and in the spiral forms of sunflowers and cauliflower—a realization that inspired Halsman's legendary photography of Dalí with a rhinoceros. **[fig. p. 75]** As Dalí fittingly said, "I am a rhinoceros, but one with a moustache."

When Dalí visited Halsman in the spring of 1953, the photographer noticed an important change in his friend's appearance: his moustache was longer than ever before. Halsman realized that "this great painter had become the great moustache of our time," and immediately pulled out his camera. Their first moustache shoot lasted three hours. Several days later, when the publisher Dick Simon saw the moustache pictures at Halsman's studio, the idea for an entire book of Dalí's moustaches was born. Halsman was excited, and he was convinced of the uniqueness of the project. Never before had there been a book about just one part of an artist's body: no book about Raphael's nose, no book about Picasso's feet... and

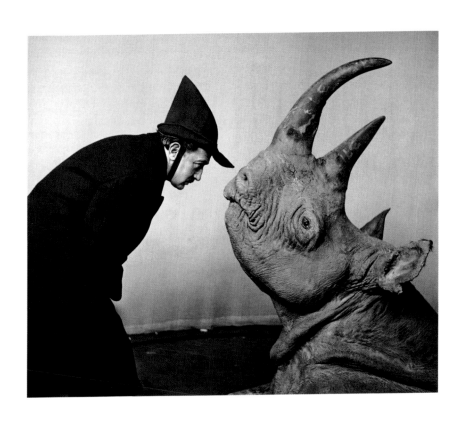

Philippe Halsman,
Salvador Dali with Rhinoceros,
1952

no book about Dalí's moustache. Nevertheless, when he told Dalí of the idea, Halsman was still unsure whether anyone would ever buy such a book. Dalí dissipated these doubts: "Nobody realizes the commercial potential of my moustache."

Halsman quickly found a way to approach the planned moustache book. He took inspiration from his 1948 book *The Frenchman – A Photographic Interview with Fernandel*, in which the French actor Fernandel (Fernand Joseph Désiré Contandin) responded to questions posed by Halsman through various facial expressions. Similarly, Halsman asked Dalí questions, and these were then published in the book. With just two exceptions, each question was accompanied not only by a photograph of the artist, but also by a written answer. In the photographs, Dalí gave a purely visual answer using his moustache, often with the aid of various props. The range of questions was quite broad. Some specifically addressed Dalí's facial hair (Halsman: "Why do you wear a mustache?" Dalí: "In order to pass unobserved."), while others addressed additional aspects of his personality, or his ideas and visions.

But the photographs do far more than just illustrate Dalí's written answers. They are all humorous or ironic, sometimes surreal, and often contrast with the written answers. For instance, where Halsman asked, "Why do you paint?" and Dalí answered, "Because I love art," the accompanying picture tells a completely different story: One end of Dalí's moustache is turned up towards his nose and the other is turned down towards his chin, so that the moustache looks like a giant "S." Halsman then added two paintbrushes so that the combination of the moustache and the brushes looks like a dollar sign. Dalí's head—with wide, staring eyes and a sly smile—is surrounded by coins.

The picture had been Dalí's idea, and when he saw it he excitedly called out, "I have the facial expression of a small rat. It is perfect." As ambiguous as Dalí's statements may be, they are excellent examples of the extremes of his personality. At the same time, however, each whisker in the photographs radiates his multifaceted and frequently contradictory personality, his true self.

The book was truly a collaborative project: some ideas for the photographs came from Halsman, others from Dalí. Although each picture features Dalí with his moustache, photographic manipulation and photomontage lend each image its own unique force of expression. Both artists threw themselves fully into the project and met repeatedly over the course of five months, during which time Halsman even put off several other assignments.

Again and again, they came up with new questions and new picture ideas. In the end, they created far more pictures than the twenty-eight photographs published in the small-format *Dalí's Mustache*. What a shame, for it meant that the world never learned that Dalí was planning an "an infinite Moustache." At some point, even the entire Halsman family caught "mustachomania." One day, Halsman's daughter asked, "Couldn't you photograph Dalí eating his moustache, as if it were noodles?" And Halsman's wife Yvonne was not the only one to become involved in the often complicated preparations for a photo shoot. One photograph required an armed escort because Dalí stuck two 10,000-dollar bills on the ends of his moustache using holes that Halsman had made using a sharp pencil. **[fig. p. 78]**

The picture was an expression of Dalí's joy at having signed a contract with Simon & Schuster, the publisher of *Dalí's Mustache*. The same 10,000-dollar bills were used in another picture of Dalí: a portrait of Dalí holding the banknotes, superimposed onto a

Yale Joel, *20.000 Dollar Dalí*
(Making of *Dalí's Mustache*, on the right:
Philippe Halsman), 1954

reproduction of Leonardo da Vinci's *Mona Lisa*. However, both photographs were banned by the Secret Service (at the time a part of the Treasury Department) on the grounds that the visual reproduction of paper money was against the law. As a result, the picture of Dalí with the bills stuck on his moustache never made it into the book. For the photomontage with the *Mona Lisa*, Halsman replaced the bills with coins so that it could be included in the book. A later edition of the book was printed using the original version with the banknotes. **[fig. p. 78]**

Published in October 1954, the wonderful book *Dalí's Mustache* went on to become a worldwide long-seller. Dalí dedicated the book to Gala, with the words: "To Gala, who is the guardian angel of my mustache also." Halsman's dedication to his wife read, "To Yvonne, for whom I shave daily."

When the book was published, the fifty-year-old Dalí's moustache was the longest of any time in his life. He trimmed it back significantly shortly thereafter—as seen in Halsman's 1966 portrait *One-Eyed Bandit* **[fig. p. 2]**—but it was with his long, pointy moustache that Dalí entered the collective consciousness.

With this absurdist book project, the moustache definitively became Dalí's trademark and the most important building block of his image. Like nothing before it, the book proved what Dalí had always demonstrated: as a malleable creative tool and a means of expressing the many sides of his personality, Dalí's moustache became both his most famous physical attribute and an important work of art in its own right.

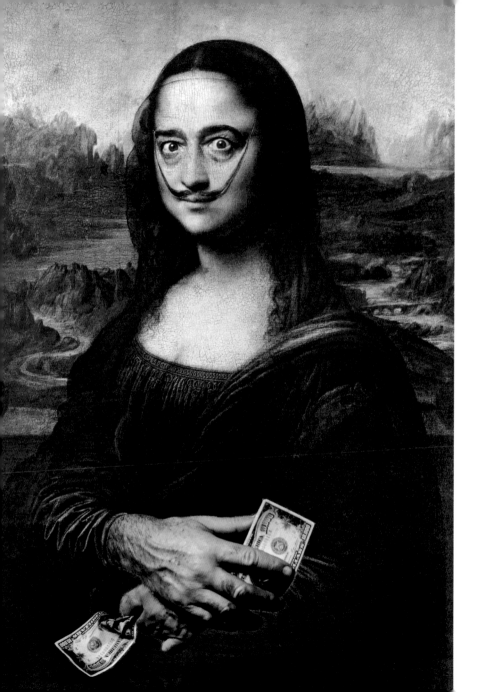

The "Mona Lisa" and Other Bearded Women

I'm never sure whether Dalí
copied transvestites from me or
I copied transvestites from Dalí.
Andy Warhol

There is something mysterious about her carefree smile. She radiates a sense of calm and grace. Her light, curly hair, shrouded in a veil, reaches nearly to her ample bosom. She is dressed in noble garments. And her dark, piercing eyes, circumscribed by dark circles, stare at us madly; her hairy, muscular hands lovingly clutch several dollar bills, and—the horror!—on her face is Dalí's moustache, its ends curling all the way up to the eyes. **[fig. p. 80]**

In 1954, for their joint book project *Dalí's Mustache*, the photographer Philippe Halsman asked Dalí what he saw when he looked at the *Mona Lisa*. Dalí immediately began to sketch her portrait (naturally with a Dalínian moustache) and answered, "A paragon of beauty." Halsman asked Dalí to pose like the *Mona Lisa*, photographed him, and then pasted Dalí's eyes, moustache, and hands with dollar bills—an ironic reference to his lust for money—into a reproduction of da Vinci's famous portrait.

But the idea of a *Mona Lisa* with facial hair was hardly new. In 1919, exactly 400 years after da Vinci's death, the Dadaist Marcel Duchamp had drawn a moustache and tiny goatee on a reproduc-

Philippe Halsman, photo from the series
Dalí's Mustache, 1954

tion of the *Mona Lisa*. Dalí was naturally familiar with this drawing, and was initially worried about engaging in plagiarism. But Halsman eased his mind: after all, their *Mona Lisa* possessed Dalí's original moustache, eyes, and hands.

Unlike Halsman's photomontage, Duchamp's readymade of the *Mona Lisa* had a title, which Duchamp had clearly written beneath the portrait: *L.H.O.O.Q.* Read in French, the letters sound like "Elle a chaud au cul"—literally, "She has a hot ass," meaning she is sexually excited. There is no doubt that Dalí was fascinated by Duchamp's *Mona Lisa*. Writing in the third person in 1963, he proclaimed that "it was inevitable that Salvador Dalí should reveal publicly" why the *Mona Lisa*, also known as *La Gioconda*, had the unique power to repeatedly provoke aggressions—aggressions that were expressed in artistic disputes, theft, or even attempts at the painting's destruction.

Speaking about Duchamp's *Mona Lisa*, he wrote that it "is a case of aggression by an artist against a masterpiece that embodies the maximum artistic idealization. It is explained by an insight of Freud whose sublime definition of the Hero is: 'The man who revolts against the authority of the father and finally overcomes it.' This definition is the antithesis of Dada which represented a culmination of the anti-heroic, anti-Nietzschean attitude to life. Dada seeks the anal, erogenous zone of the *Mona Lisa*, and while accepting the 'thermic agitation' of the Mother as a Work-of-Art, rebels against its idealization by masculinizing it. Dada paints the mustaches of the father on the *Mona Lisa* to enlist his aid in the denigration of the Art. In this gesture, the anti-artistic, anti-heroic, anti-glorification, and anti-sublime aspects of Dada are epitomized."

In an interview, Dalí explained the real reason why he admired Duchamp for this readymade: "I am a very great admirer of

Marcel Duchamp, who happens to be the man who has made those famous transformations on the face of the *Gioconda*." Duchamp's true greatness, he revealed, lay in the fact that "he drew a very small moustache on her, a moustache that was already Dalínian."

Unlike Duchamp, Halsman didn't just give the *Mona Lisa* a moustache. He did something much more wonderful: he turned Dalí into the *Mona Lisa*—and simultaneously turned the idealized image of femininity into Dalí, including his seemingly so masculine attributes. In fact, Dalí had once said of the *Mona Lisa*: "She is me, and I am her"—this being both masculine and feminine, which reveals much of Dalí's personal feelings and ideas of masculinity and femininity, and the union of the two.

The roots of these feelings and ideas began to form in 1929. It was an important year for Dalí, because it is when he first met Gala. Dalí, who at the time was a mentally unstable and complex-ridden artist with a manic laugh barely capable of taking care of himself, initially saw her as his savior. "I did not go mad, because she took over my madness," Dalí later confessed. Gala prepared the path the young artist could follow in order to truly become Dalí. But she was not just his savior; she was also the first woman in his life, and would soon become mother, wife, muse, manager, and goddess. And much more.

Gala was the one who first enabled him to reach the previously unknown female side of his personality—his genius, as he called it. Since he also saw his twin in Gala, he believed that their being together had unleashed the same process in her as well. If we look at the young couple dressed nearly identically in a photograph from 1930, can there be any doubt that he was right? **[fig. p. 85]** Writing later in his *Unspeakable Confessions*, Dalí explained that,

with Gala, there were four of them: "woman-man-Dalí; man-woman-Gala."

For a time in the early 1930s, Gala was so synonymous with the feminine aspect of Dalí's personality that he began signing his paintings "Gala-Dalí." Through this egalitarian gesture, which grew out of the fully felt masculine and feminine sides of his personality, Dalí felt called upon to become what his first name, Salvador, demanded that he be: a savior who would rescue modern art from torpor and chaos. He also said that it was the reason for his artistic superiority over a certain other Catalan artist: "My superiority over him lay in my name being Gala-Salvador-Dalí and knowing that I was the savior of modern art that he was bent on destroying while his name was simply Pablo." Where Dalí usually kept his views on the masculine and feminine aspects of the soul to himself, here he revealed that he saw destruction as a purely masculine principle, and salvation and protection as a feminine quality.

Halsman's photomontage of Dalí and the *Mona Lisa* shows the woman whom many consider a representation of "idealized femininity," with the addition of several of Dalí's typically masculine sex characteristics. One thing becomes clear: this simultaneously masculine and feminine body can be understood as symbolizing Dalí's inner life, which was determined by both masculine as well as feminine qualities. In fact, Dalí was probably aware that people had been arguing since the fin de siècle that the beauty of the *Gioconda* (nobody had drawn a beard on her yet) was determined by masculine features, as represented by the "cerebral authority of the man of genius," as well as feminine characteristics, observable in the "gentile lady's voluptuousness."

Halsman's mustachioed *Mona Lisa* was just one of Dalí's artistic demonstrations of the union of the masculine and feminine within

Unknown, *Salvador Dalí and Gala*,
ca. 1930

himself. In February 1935, when Joella Levy and Caresse Crosby organized the *Dream Betrayal* masquerade ball in New York in honor of Gala and Dalí, Dalí arrived in a very special outfit **[fig. p. 86]**: his hair was covered by white gauze tied tightly under his chin that lent him the aura of a nun. He wore a black robe over a white shirt, inside which was a display case with a small bra illuminated by a tiny lamp: a reference to his hostess, Caresse Crosby, the inventor of the first modern brassiere. He wore a glittering bracelet, a matching necklace, painted eyebrows, red lipstick, and his resplendent Menjou moustache. The outfit was not just a surreal costume; it was also an early expression of the union of the masculine and feminine aspects of his personality. Dalí saw this union of the sexes not just as a source of individual fulfilment for himself and Gala, but as a

Salvador Dalí in a costume at the "Dream Betrayal"
masquerade ball at the Coq Rouge, New York,
February 18, 1935 (news report with photographs)

universal ideal for all people that would enable perfect beauty and absolute creativity. With these ideas he was not alone among the Surrealists, who saw apparent contradictions such as dreaming and waking, conscious and unconscious, real and imaginary—and male and female—not as insurmountable opposites but as something to be merged into one.

Whereas for Dalí and Gala this ideal union of masculine and feminine described a spiritual state, Dalí was also fascinated by people in whom both these aspects were physically visible. In the early 1960s, he liked to visit cabaret shows at transvestite clubs, and transvestites were soon a regular part of his "court" during afternoon tea at the Hotel Le Meurice in Paris or during his dinners and parties in New York. But one being with an androgynous aura enraptured Dalí like no other: in the mid-1960s, he met Amanda Lear, **[fig. p. 90]** a model with artistic ambitions who later gained fame as a disco queen.

With Gala's hesitant blessing, Amanda and Dalí quickly became an inseparable team, and more than a few people were convinced that they were lovers as well. Once, Dalí told Amanda that his dream was the blending of the sexes and that his ideal being was the hermaphrodite, which is why he gave all the female members of his "court" male names and vice versa. But Amanda kept her old name; apparently, her androgynous appearance made this unnecessary. When rumors began to circulate that Amanda Lear was a transsexual, a man who had undergone a sex-change operation, they seemed to have no effect on Dalí's enthusiasm for her—quite the opposite, in fact. Dalí enjoyed appearing at public receptions and private events with her at his side. When the Marquis de Cuevas invited Dalí and Amanda for a tea party where the guests were expected to be "in proper attire" (a priest came in

full regalia, Greta Garbo as Garbo with black sunglasses, and the bullfighter Luis Minguel Domínguín as a torero), Amanda showed up with a Dalí moustache. Dalí had found his bearded woman, whom he reinvented over and over again. This androgynous ideal can be found in the *Tarot Universal Dalí*, his personal version of traditional tarot cards apparently commissioned in the early 1970s for the James Bond movie *Live and Let Die*, although it was never used in the film. On one of the cards—a reproduction of François Clouet's portrait of Elisabeth of Austria, the Queen of France—Dalí painted a crown on her head, placed her hand on a cup, and added a blue aura with a heart and burst veins resembling lightning bolts. She is also wearing a blue moustache and goatee—the same kind of facial hair that he had painted on his self-portrait from 1926. **[fig. p. 23]** The card is the "Queen of Cups," which in tarot divination traditionally unites opposites.

A moustache and goatee can also be found on the picture of a woman in a very special protest pamphlet published in 1960. **[fig. p. 89]** It shows a part of Dalí's 1952 painting *Assumpta Corpuscularia Lapislazulina*, which depicted Gala as the Madonna. But the facial hair on the pamphlet was not Dalí's doing. The bearded Gala was the idea of the twenty-five Surrealists who had signed the pamphlet. Like Duchamp's *Mona Lisa*, this picture also bore the label *L.H.O.O.Q.*—with the addition of the words "comme d'habitude" (as always) in parentheses.

The title was not only meant to signify that Gala, who had frequent relationships with young men, was far from being a saint. This bearded Gala had been created in order to irritate her cuckolded husband. It was also an attack on Duchamp who, as the organizer of the International Surrealist Exhibition, had gone over the heads of André Breton and the other Surrealists and

WE DON'T **EAR** IT THAT WAY

Une exposition internationale du surréalisme se tient actuellement à New-York, galeries d'Arcy. Un événement aussi fâcheux qu'imprévisible en a marqué le vernissage. Nous apprenons en effet, de source indirecte, que Salvador Dali en personne y a été reçu avec les égards dus à un invité de marque. Ceci a été rendu possible par l'intrusion, parmi les toiles de l'exposition, d'une "Madone" (*) de sa façon sulpicienne, de dimensions considérables et d'exécution récente, qui ne pouvait y figurer à aucun titre.

Seul des quatre organisateurs : Marcel Duchamp, André Breton, Edouard Jaguer et José Pierre, le premier se trouvait sur place, fondé à prendre toute décision de dernière heure. Les trois autres ignorent à ce jour sous quelles pressions ou en raison de quelles considérations stratégiques il a pu se déterminer à faire à Dali, dans une entreprise qui nous est commune, cette part exorbitante.

Depuis longtemps nous honorons bien trop les ressources de son esprit pour lui faire l'outrage de penser qu'il ait pu, fût-ce un instant, être dupe de cette dialectique fallacieuse, selon laquelle c'est aujourd'hui le conformisme qui recèle le levain de la subversion.

La conjoncture politique en France, dans ces premiers jours de décembre 1960, nous oblige à ne pas différer d'un instant la présente protestation. Moins que jamais à nos yeux l'aventure esthétique et ses "à-côtés" scandaleux à bon compte ne sauraient se suffire à eux-mêmes. Alors qu'ici les intellectuels qualifiés luttent en pleine conscience pour défendre ce qui reste de liberté d'opinion et d'expression, nous nous devons de rappeler que Dali a été exclu du surréalisme il y a plus de vingt ans et que nous n'avons cessé de voir en lui l'ancien apologiste d'Hitler, au demeurant le peintre fasciste, clérical et raciste, ami du Franco qui ouvrit l'Espagne comme champ de manœuvres à la plus abominable barbarie qui fut jamais.

An international exhibition of surrealism is now being held in New York at the D'Arcy Galleries. Its opening has been marked by a very unexpected and annoying event: Salvador Dali's appearance on the premises, his formal introduction with respects due to a high-ranking guest, and, most of all, the deliberate intrusion, amongst the other exhibits, of a portentous *Madonna* (*), painted in his most clerical manner, and which its large dimensions, added to its recent execution, should have excluded from such a gathering.

Of the exhibition's four promoters (Marcel Duchamp, André Breton, Edouard Jaguer and José Pierre) only the first was present on the spot, and able to take any last-minute decision as befitted the incident. The last three still ignore, at this very minute, under which pressures, on wich strategical motives he could concede Dali, in such a collective demonstration, this exorbitant part.

We respect him too much, we have too long respected the resources of his mind to believe he could yield, were it a second, to such deceptive dialectics following which conformism should provide nowadays the only yeast of subversion.

France's present political climate in these very first day of December 1960, make it at once imperious for us to issue this protest. Never less than now have the aesthetical adventure and its cheap, notorious *asides* appeared self-sufficient. At the particular moment when qualified intellectuals are consciously fighting for the defense of whatever freedom for thought and expression as is yet left to them, we remind everyone concerned that Salvador Dali, more than twenty years ago, was expelled from surrealism. More than ever do we see in this man, Hitler's former apologist, the fascist painter, the religious bigot, and the avowed racist, friend of Franco, who opened Spain as a drill-ground for the most abominable surge of barbary the world has yet endur

L.H.O.O.Q.
(COMME D'HABITUDE)

(*) Intitulée par lui : *l'Oreille anti-matière.*

(*) Entitled by him: *The anti-matter ear.*

Robert BENAYOUN, Jean BENOIT, Guido BIASI, Vincent BOUNOURE, André BRETON, CORNE
Gianni DOVA, Yves ELLEOUET, Roland GIGUÈRE, Radovan IVSIC, Edouard JAGUER
Jacques LACOMBLEZ, Juan LANGLOIS, Gérard LEGRAND, Julio LLINAS, E.L.T. MESEN
José PIERRE, Carl-Fredrik REUTERSWÄRD, Jean SCHUSTER, Claude TARNAUD, Jean TI

Il a été tiré vingt-cinq exemplaires sur papier couché vert d'eau, odornés de quelques poils de la Vraye

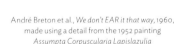

André Breton et al., *We don't EAR it that way*, 1960,
made using a detail from the 1952 painting
Assumpta Corpuscularia Lapislazulia

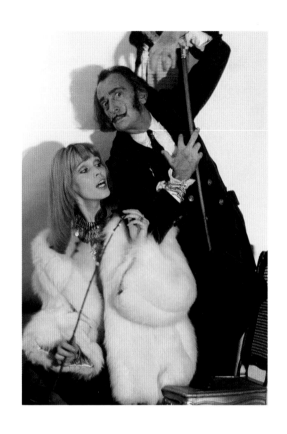

Giancarlo Botti,
Salvador Dalí and Amanda Lear,
1960s

had approved the inclusion of a painting by Dalí. But in the eyes of the Surrealists, Dalí was no longer one of them. In their pamphlet, they called him an admirer of Hitler and a friend of Franco. Dalí's response to the pamphlet is unknown, but he must have secretly enjoyed the fact that, with twenty-five copies of their tract, the authors had included a small cellophane bag with a miniature Dalí moustache. **[fig. p. 89]**

An attached note claimed that it consisted of the hairs of the "true moustache." Dalí could not have wished for a greater homage to his moustache by the Surrealists.

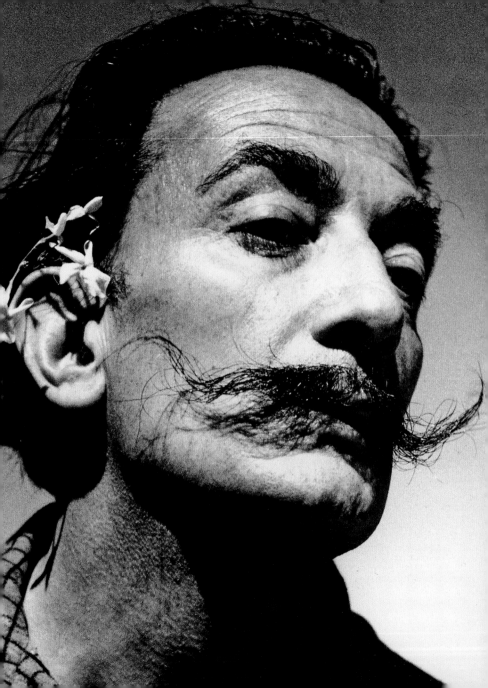

Moustache Wax 1, or: The Anti-Nietzschean Moustache

For one thing is certain:
I hate simplicity in all its forms.
S.D.

As the tips of Dalí's moustache grew longer and longer in his American exile, there came a point when he needed help. Under no circumstances were his whiskers allowed to hang down. After all, he wanted to show the world an "ultra-cheerful and mysterious moustache," and so he had to style his moustache every day with wax. Saliva and cleaning his fingernails on his whiskers before mealtime were simply no longer enough to do the trick.

If ever the hairs of Dalí's moustache were not in their usual position when he went out in public, it immediately became a news item. After a long night of partying with Dalí, one guest told a reporter, "I must report that the right half of his moustache, though strongly waxed as usual, was slightly bent."

Even when he was not in public, Dalí's moustache always had to be properly waxed. For only a waxed moustache could fulfill the special role it played during painting, as Dalí described in his 1948 book *50 Secrets of Magic Craftsmanship*. Number 18 of his magic secrets was the notion that a moustache such as his could

Liselotte Strelow, *Salvador Dalí with Nietzschean Moustache*, 1953

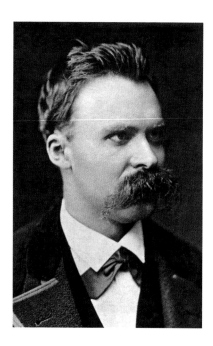

act as a dust magnet, and that each particle of dust caught on the moustache is one particle less on the painter's canvas. Another advantage of the moustache as dust magnet was that it kept dust from getting in the painter's nose. After all, just imagine the consequences of a painter's sneeze on his concentration and on the painting itself. Since, however, a beard captures all manner of dust and debris, Dalí emphasized the need for daily hygiene: "Mustaches must be frequently washed, as is done so instinctively by the animals who wear them."

Every evening, Dalí washed the wax out of his moustache, and every evening it was the same: his moustache literally collapsed,

Nietzsche with walrus moustache,
undated

as he once described on a television show. One time, however, he even appeared before a camera with wild, drooping whiskers: in 1953, when the photographer Liselotte Strelow visited him at his house on the Costa Brava.

Strelow's portrait, **[fig. p. 92]** taken in Port Lligat, is a marvelous document, because it says so much: It shows Dalí's moustache in an almost "primal state," and (by its absence) reveals the power and possibility of good moustache wax. Not coincidentally, Strelow called her photograph *Salvador Dalí with Nietzschean Moustache.* Dalí found the great philosopher's moustache "depressing, catastrophic" (regardless of the fact that it, too, experienced various metamorphoses), and so he dubbed his the "anti-Nietzschean moustache," since it was not "burdened by Wagnerian music and mist."

Dalí saw Nietzsche as a destructive genius—incidentally, just as he viewed the beardless Picasso. But he also loved to spread confusion, and so he later proclaimed himself "the superperson, the Nietzschean Superman." Here we should recall Nietzsche's influence (in terms of both his ideas and his facial hair) on the young Dalí, whose first beard, a set of sideburns, had been inspired by the German philosopher. But all that lay several decades in the past, after reading *Thus Spoke Zarathustra*, when Dalí had resolved to one day outdo Nietzsche—in terms of facial hair as well. **[fig. p. 94]** Even as a young man, Dalí already knew how he would go about it: his moustache would be twisted up, "imperialistic, ultrarationalist, and pointing to heaven, like vertical mysticism, like the vertical Spanish syndicates!"

Drooping whiskers reminded Dalí of Nietzsche, who (as Dalí put it) was crazy like him, but unlike him was also insane. When Philippe Halsman asked Dalí in 1954 what he considered ugly,

Dalí answered, "disorder," and referred to Nietzsche's drooping moustache. Naturally, Dalí and Halsman's joint book project *Dalí's Mustache* was only possible with a great deal of Hungarian moustache wax. Only this wax was capable of turning Dalí's whiskers into the kind of flexible and pliable material that was just waiting to be formed by the artist's hands. Moustache wax was clearly of immense importance.

By the mid-1960s, however, Dalí had found a replacement for this Hungarian wax, and he had Babou **[fig. p. 97]** to thank for it. Babou was Dalí's ocelot (supposedly a gift from the Colombian president), who often accompanied Dalí on a leash. But not everyone appreciated Dalí's companion: in a restaurant in Manhattan the animal caused several guests to panic, to which Dalí responded that it was an ordinary house cat that had been painted like an ocelot.

It is unclear how Dalí hit upon the idea of mixing a pinch of Babou's excrement with wax in order to create his ultra-individual moustache wax. But Dalí's fascination with his own excretions is well documented, and he even planned a philosophical treatise on the subject. Even when he was first wooing Gala, he smeared his body in a mixture of fish glue, goat manure, and lavender in order to smell like a ram and thus gain her favor. In his *Diary of a Genius*, Dalí confessed, "I am dumbfounded by how little philosophical and metaphysical importance the human mind has attached to the capital subject of excrement."

Around the time that Dalí was waxing his moustache with Ocelot dung, his whiskers had begun to go gray, and so he started coloring them. But instead of going to a barber, who would probably have used professional hair dye, he simply used a black pen from home.

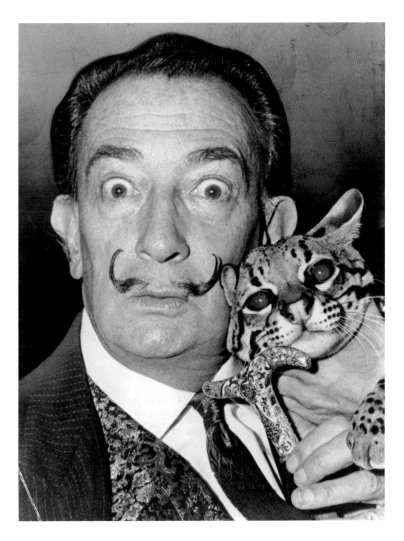

Roger Higgins, *Mr. Salvador Dalí
with his Ocelot Babou at The St. Regis,
New York*, 1965

Pinaud moustache wax with brush

Amanda Lear remembers that, as a result, when Dalí kissed a woman it often left an imprint of his moustache on her face. But Dalí does not appear to have used his ocelot wax mixture for very long. Enrique Sabater, Dalí's personal assistant and secretary from 1968 to 1981, remembers that he always purchased "Pinaud Original Moustache Wax," **[fig. p. 98]** made by a company that had been founded in 1810 in Paris but that had long ago conquered the American market. Dalí called it "Hungarian wax" as well, and was convinced that even Marcel Proust had used this brand, emphasizing that Proust had used it to create an entirely different moustache mood. Naturally, Dalí found Proust's whiskers psychotic and depressive.

There was one more substance that Dalí used for many years in order to style his moustache.

But that is another story for another chapter in this book.

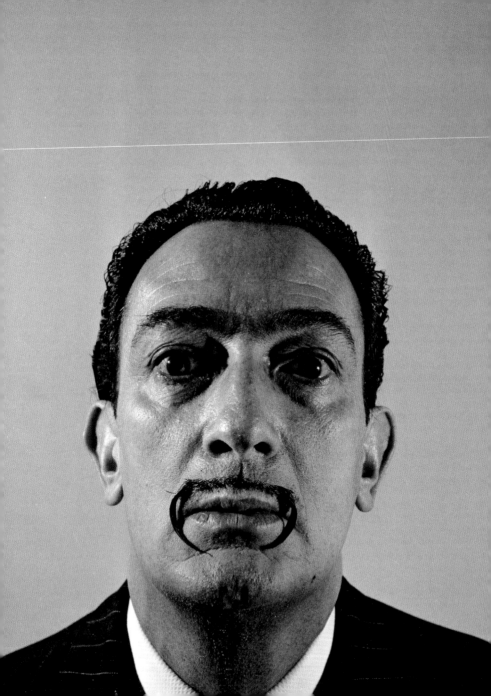

Hairy Stories:
The Beatles, Delilah and Samson

My moustaches are
the fangs of my personality.
S.D.

Dalí was convinced of the magical and strength-giving powers
of hair. It is thus no wonder that he was fascinated by the story
of Samson and Delilah. The Biblical hero Samson, known for his
immense strength, performed many wondrous deeds, battled a lion,
and even defeated a thousand Philistines. An angel had proclaimed
that he would be invincible as long as he did not cut his hair or
beard. But Samson fell in love with Delilah and misfortune took
its course: he told her the secret of his strength, but she had been
bribed by the Philistines, and one night as he lay sleeping, she cut
his locks and the Philistines captured and blinded him.

In 1922, while still a student living at the Residencia de Estudi-
antes in Madrid, Dalí first experienced with his own body how
much truth there was to the Old Testament story. After several
months at the Residencia, he had decided to change his look. His
black floor-length coat, his black tie, and especially his long, flowing,
curly hair with which he had wanted to let everyone know that he
was an artist had had the opposite effect: the young man with

Willy Rizzo, *Salvador Dalí*, 1966

the romantic aura had become an object of ridicule. So he visited a barber. And as the first locks fell to the ground, he remembered the story of Samson—and for the first and last time in his life, his faith in himself was shaken. Someone who loses his faith in himself is probably also not at peace with himself or with the world. But it would be many more years before someone showed that the freedom of long hair could also promote peace.

Decades later, in 1968, when advancing age had already forced Dalí to bid farewell to more than a few hairs on his head, he received a visit from Peter Brown. Brown was the former right-hand man of The Beatles' manager Brian Epstein and had been looking after the Fab Four's special affairs since Epstein's death the previous year—and the reason for Brown's trip to Port Lligat was very special indeed. John Lennon wanted to give the band's drummer, Ringo Starr, a one-of-a-kind birthday present: a hair from Dalí's moustache. The origins of this idea remain unknown, but there is no doubt that the members of The Beatles had all appeared on the cover of their most recent album (*Sgt. Pepper's Lonely Hearts Club Band* had been released the previous summer) wearing moustaches—each in his own individual style. Perhaps Lennon truly wanted a unique present from Dalí the superstar that no gallery could offer, but Dalí had his own theory. The real reason could only be that Lennon's new partner, the artist Yoko Ono, wanted the hair for herself, and the story about Ringo was just a pretense.

Many years later, Amanda Lear recounted what Dalí thought of Yoko Ono at the time: "Dalí thought that Yoko Ono was a witch." Dalí's belief in the profound trueness of the story of Samson and Delilah had not wavered by a hair's breadth. He was convinced that Yoko Ono would have power over him if she possessed one

of his hairs. His abilities, his inexhaustible powers, and his genius were in danger!

Still, Dalí never missed a business opportunity. Determinedly, he went out to look for a special plant that he had recently discovered near his home. This plant had a unique characteristic: its stalks rolled and unrolled in a particular rhythm and curled up like a corkscrew. In a strange way, these thin stalks resembled Dalí's long whiskers. Once, he even stuck them to the ends of his moustache and proclaimed the invention of the radar moustache. And so he gathered some stalks and presented Brown with his floral whiskers. Perhaps it was his power of persuasion, but in the end Brown bought them for 10,000 dollars. As Amanda Lear later explained, "It amused him to rip people off."

The following March, Dalí had the chance to meet John Lennon and Yoko Ono in person. The date—March 20, 1969—was a special one, for Lennon and Ono had just gotten married in Gibraltar and had subsequently traveled to Paris, where they lunched with Dalí. The group seemed to get along splendidly: Lennon and Ono launched into an out-of-tune song, and Dalí picked up a baked fowl by his teeth and turned numerous tables at the upscale restaurant upside down. He didn't need any drugs. "I am drugs," he said.

Several hours later, Lennon and Ono were in the presidential suite of the Hilton Hotel in Amsterdam, accompanied by an expectant mob of reporters, for a one-week "Bed-In for Peace." The happening showed the world the incredible power of hair **[fig. p. 105]**: hanging over their bed were two signs with the words "Hair Peace" and "Bed Peace." The long-haired (but beardless) Lennon proclaimed, "Anybody could grow their hair for peace or give up a week of their holiday for peace or sit in a bag for peace." In bed, he sang: "Stay in bed, for bed-in, for peace of the world, stay in bed,

grow your hair. Grow your hair." Unfortunately, Lennon had completely forgotten about the power of facial hair. In the spirit of Lennon and like his hairy brother-in-arms, Dalí later said, "To have a mustache, a beard, long hair, to me seem to be essential conduct in a self-respecting society."

And he added, "Indeed, there is no reason to make a display of one's beard or hair as aggressive antennae if one has nothing to say, or protect, or go after."

John Lennon and his wife of a week Yoko Ono
in their bed in the Presidential Suite of the
Hilton Hotel, Amsterdam, March 25, 1969

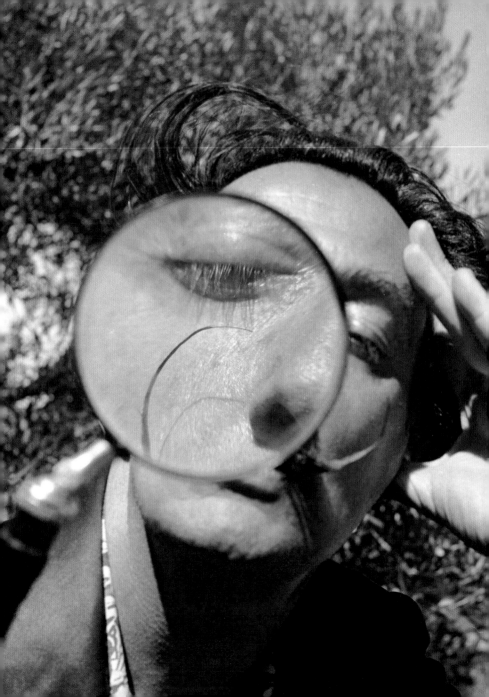

"Je suis fou": Dalí's Moustache As a Star of TV and Advertising

The moustache depends solely on the will
of your personality, and human personality
is defined fundamentally as the personal ability
to capitalize on even the smallest parcel
of your person, down to the last whisker.
S.D.

In 1950, Dalí designed a flacon for *Monsieur Marquay*, a new men's perfume by the Parisian perfume company Marquay. The flacon had an asymmetrical angular form, and beneath the spray nozzle in the shape of a top hat was a small bowtie—at the time a common accessory for every true gentlemen. The box was also designed by Dalí: on one side was the perfume's name, and on the other were several slightly abstract variations on Dalí's moustache. **[fig. p. 108]** Executed in a lively fashion, they look almost like paint splatters and resemble his paintings from that year. One was even used as a pattern on an artistic carpet. **[fig. p. 109]**

Although this was several years before Dalí's moustache reached its maximum length, the packaging design was Dalí's first attempt at establishing his moustache as a trademark. The

Charles Hewitt, *Larger Than Life*, 1955

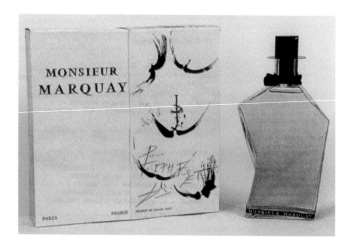

plan was a grand success, as Dalí proudly reported several years later, comparing the world's most famous moustache with its most famous fragrance—which, not coincidentally, also contributed to the successful construction of a brand and a myth: "No. 5 was to Coco Chanel what my mustache was to my character."

By 1954, when Dalí's moustache was the longest it would ever be, he had not only become a brand name, but he had also become safe for mass consumption. Even before Dalí and Philippe Halsman published an entire photographic book dedicated to his moustache, a television company offered him 500 dollars for ten minutes of filming his moustache. But Dalí was also willing to come into the studio for free. He loved television and television loved him: a love that would never be as strong as in the United States in the 1950s. Even though many of the shows were not explicitly about his moustache, sooner or later the subject always came up. Let us take a brief look at three of his television appearances.

Monsieur Marquay perfume flacon
designed by Dalí

When Dalí appeared in a 1954 episode of the game show *The Name's the Same*, the panel's job was to guess Dalí's greatest wish: to draw the show's host, Robert Q. Lewis. But the panelists did little guessing, and soon most of the conversation centered around Dalí's moustache. Dalí said that it was the most serious part of his personality and revealed to the dumbfounded panel which moustache wax he used. There was much joking and laughing.

The next year he was back as a guest on the same show. Once again, the panelists had to guess a wish of his: indeed, a great desire. "Does it involve something artistic?" "Yes." "Does it involve something tangible?" "Yes." It soon became clear that (of course) it had something to do with his moustache. In fact, what Dalí wanted was that "all men wear a moustache like mine." At the end of the show, Dalí pasted a moustache on all the male panelists, and used a marker to draw one on the host's face. It was a grand combination of showbiz and Surrealist performance.

Artistic carpet by Manufacture
d'Aubusson with moustache motif
designed by Dalí in 1950

In 1957, Dalí was a guest on *What's My Line*, in which a panel of celebrities wearing masks over their eyes had to guess the guest's profession. "Are you associated with any of the arts?" "Yes." "Would you ever have been seen on television?" "Yes." "Are you a performer?" "Yes." "Would it be the sort of exploit that might possibly reach the front page of a newspaper?" "Yes." "Would you be considered a writer?" "Yes." "So you can do several things?" "Yes." "Do you ever do any drawing like comic strips?" "Yes." The panelists asked and asked, until finally one of them came up with the idea of asking him whether he could use his moustache to paint. "Yes." Laughter, applause. And of course the host made sure to hold up Dalí and Halsman's book *Dalí's Mustache* for the camera.

Dalí once called television the "medium of degradation and feeblemindedness of the masses." And yet, nowhere else could he market himself as well. If you wanted to meet Dalí in person, you needed either a lot of luck or a lot of money. And it didn't hurt to be a millionaire if you wanted to buy one or more of his works. The mass media, and television in particular, not only brought Dalí the showman into millions of living rooms—it also made him more comprehensible and easier to consume.

The masses loved Dalí and Dalí loved the masses. Soon he was making good money, thanks in part to his moustache. Although during his time in exile Dalí had done advertisements for a wide variety of products—often using ants, crutches, melting clocks or other motifs commonly found in his paintings—now things really took off. According to his secretary, he received an average of 500 offers a year. Everyone wanted an advertisement or even a product for the masses designed by the great master, or they wanted the "Divine Dalí" to be the face of their marketing campaigns.

Dalí created cognac bottles and ashtrays for Air India, designed swimsuits, ties, perfume bottles, lipstick, and the logo for Chupa Chups lollipops, and appeared in an ad for white shirts. Each contract earned him much money, of which he could never have enough. There were no limits—neither in the amount nor how he got it. In 1958, Dalí told a friend that he liked to stroll through the most expensive hotels in New York, to display his moustache at luxury restaurants, or to promenade up and down Fifth Avenue in order to go "fishing" for clients. According to the theater director Peter Brook, Dalí liked to ask people if they had a dollar. It was a game he enjoyed: "I can make about one hundred dollars a day this way." Later he hit upon the lucrative idea of charging for his autograph.

Still from the Goodson-Todman
game show *The Name's the Same*
(January 3, 1955)

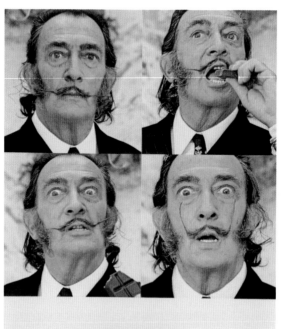

Advertising poster for Chocolat Lanvin
featuring Dali, 1968

Dalí landed his greatest advertising coup in 1970, and again his moustache took center stage. It was a French television commercial for Lanvin chocolates. **[fig. p. 112]** The seven-second ad shows Dalí with his favorite accessory—his cane—holding a bar of chocolate into the camera. His moustache is in a vertical position. He breaks off a piece of chocolate, sticks it into his mouth, and chews noisily. In a close-up, the ends of his moustache begin to quiver and move, then they turn up towards his eyes. Staring wide-eyed, Dalí proclaims, "Je suis fou du Chocolat Lanvin" (I'm crazy for Lanvin Chocolates). For this moustache ad, he earned a fee of one million dollars per minute. The shoot took ten minutes. In an interview with the actress Melina Mercouri several years earlier, Dalí had said, "I don't think I like publicity in itself. What I like is to prove to me that I exist, symbolically."

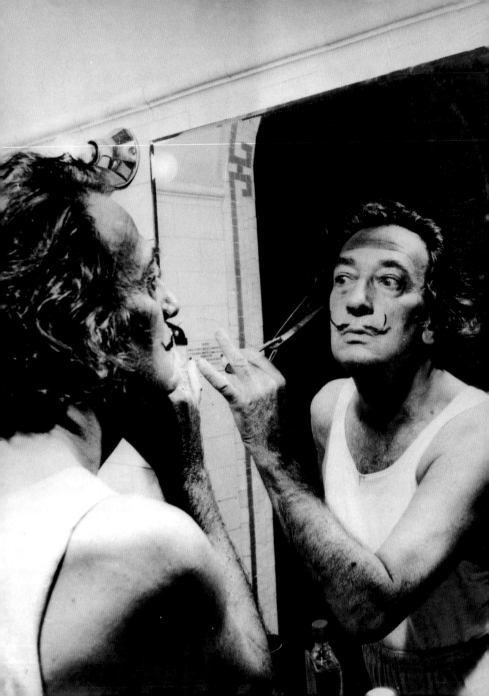

Cutting Back

My audience mustn't know
whether I'm spoofing or being serious;
and likewise, I mustn't know either.
I'm in a constant interrogation:
where does the deep and philosophical Dalí begin,
and where does the loony and preposterous Dalí end?
S.D.

In June 1964, the American edition of *Playboy* published an interview in which Dalí announced the unimaginable: in two years, he would cut off his moustache. He even revealed why. Since he had lost so much hair on his head, he would soon have to wear a toupee—and he rejected the notion of wearing a moustache and a toupee at the same time. Dalí announced that he would cut off his moustache during a grand liturgical ceremony in Venice, naturally in the presence of television cameras and in front of a large audience. And from that day on, he would wear two wigs: a gray one during the day and a black one at night.

Dalí expected this outer transformation to bring about revolutionary things: "And with this gesture, the monarchy will arrive back in Europe. General Franco will decide to reestablish the monarchy in Spain, and in this moment of the return of the monarchy, *everybody* will wear wigs again, and there will be a renaissance of ornamentation and plumes and tremendous

Paul Popper, *Salvador Dalí Cutting
his Mustache*, 1964

quantities of little cakes and candles. Art and painting will flourish. And so will Dalí."

Be that as it may, shortly after the interview the rumor spread that Dalí had cut off his moustache and sold it for two million dollars. After all, Dalí was capable of anything. When the composer Igor Stravinsky read the news in the paper, he enthusiastically remarked, "When one has moustaches like that, one would be a con not to sell them."

Stravinsky knew firsthand just how indispensable Dalí's moustache was for his self-presentation. Sometime around 1954, Stravinsky was staying at the St. Regis—the New York hotel where Dalí inhabited an entire suite during the winter months—when he heard a mysterious sound in the hallway. Then he saw Dalí, steadfastly ringing a little bell. When Stravinsky asked him what he was doing, Dalí answered, "I carry it and I ring it." To this Stravinsky, who had his own interpretation for this activity, said, imitating Dalí's Catalan accent, "So people will see my moustaches."

Stravinsky's approval of Dalí cutting off and selling his moustache may have been authentic, but the news report was not. When the photographer Philippe Halsman heard the news, he was sure it could not be true. For this expert on Dalí's moustache, Dalí without a moustache was like a television without an antenna. It simply made no sense.

And so, in the fall of 1964 the *Life* magazine photographer traveled to Spain, where he and Dalí hatched a plan, as Halsman later recounted in a magazine report: "To prove to the world that his moustache was still as strong as ever, we decided to photograph him suspended by the ends of that elegant growth—from a helicopter." Late that year, a photograph appeared in the international media showing Dalí hanging from a flying helicopter by a string attached

Philippe Halsman, *Salvador Dalí's Performance with Helicopter at Port Lligat*, 1964

Werner Bokelberg,
*Salvador Dalí Coloring His Moustache
at Port Lligat*, 1965

to the ends of his moustache's "metaphysical antennae." **[fig. p. 117]** The choice of a helicopter was no coincidence, for Dalí considered it the "mystical device par excellence." Of course, the photograph involved a fair amount of trickery on the part of Dalí and Halsman. The strings tied to Dalí's moustache were not attached to the helicopter, but were held up by two assistants standing on ladders. And although Dalí appears to be floating in mid-air, he is actually standing on a giant plate of Plexiglas, with Halsman taking the photograph from below. Nevertheless, the helicopter hovering over Dalí's head was real, and its rotors created such a downdraft that the "floating" artist found it difficult to stay on his feet.

What Dalí didn't mention in his *Playboy* interview was that, on one occasion, his moustache was indeed cut off in front of an audience. But it had not been planned, and it was done without his permission. One June evening in New York in 1959, the young Spanish artist Joan Gardy Artigas and some friends were attending the opening of an exhibition by Antoni Tàpies at the Martha Jackson Gallery. Dalí was there as well. Suddenly, Artigas appeared with a pair of scissors in his hand, stood behind Dalí, and cut off the twisted ends of his moustache. An air of nervousness filled the room. When the dumbfounded Dalí asked Artigas why he had done it, he smiled and answered, "It had to happen someday."

But had Artigas cut off Dalí's real whiskers? Again and again, rumors surfaced that Dalí's barber Llongueras had produced an entire palette of moustache toupees for him—just in case of an assault on his moustache. Be that as it may, the question of fake versus original follows the life and work of Salvador Dalí like a mystical fly circling his moustache. For Artigas, it was the kind of surreal act everyone should perform at least once in their lives.

In May 1965, nearly one year after Dalí's interview appeared in *Playboy*, the German photographer Werner Bokelberg accompanied a journalist to Port Lligat on an assignment for *Stern* magazine. Instead of the planned reportage, however, Dalí spent eight days presenting a one-of-a-kind happening that Bokelberg captured in countless photographs **[fig. p. 118]** and that Dalí later used in a book.

The book, published in 1966, again contains Dalí's announcement that he planned to cut off his moustache. This time, too, he named the same reasons as in the 1964 interview. But instead of giving a date for his liturgical ceremony, he merely said that he would do it "someday." And so, two years after his announcement in *Playboy* magazine, nothing happened. He kept his moustache, Franco was still in office, there were no wigs, and the Renaissance in the fields of ornamentation, feathered hats, and the pastry arts remained a distant dream.

But Dalí did do something that went against his earlier theory: every now and then the mustachioed Dalí wore one of several wigs, created for him by his trusted longtime barber Luis Llongueras, including one in the style of Velázquez **[fig. p. 121]** and one à la Baudelaire. Still, Dalí never forgot his promise to one day cut off his moustache. He told Llongueras that he planned to cut off the tips of his moustache at a press conference in front of rolling cameras. But instead of cutting off his real moustache, he planned to roll it up under a moustache toupee and to cut the tips off the toupee. Llongueras set to work, and in the end Dalí traveled to New York with the completed toupee. But even then no moustache was cut, not even a fake one.

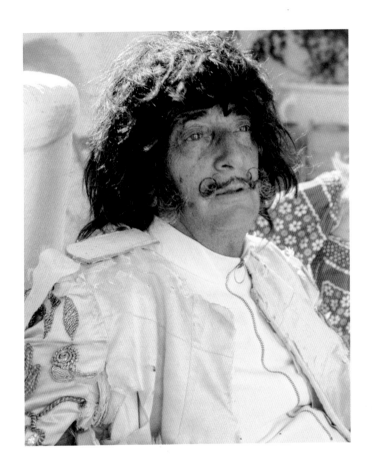

Gianni Ferrari, *Dalí on Spanish Television*,
1969

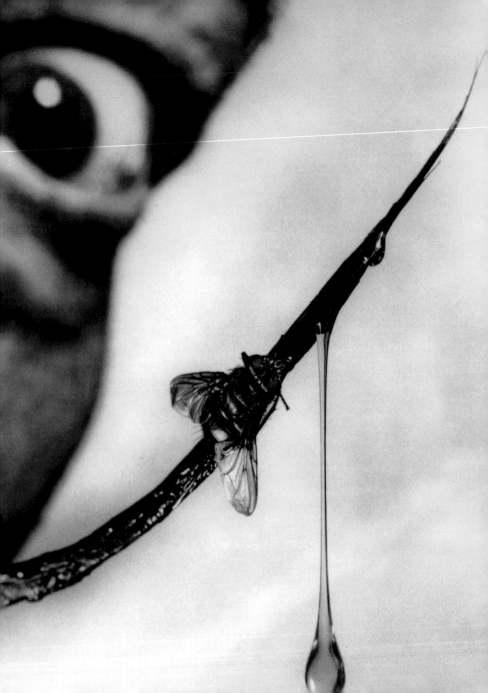

Moustache Wax 2, or:
Philosophical Flies

The best moment is
with many flies around.
Then I work well.
S.D.

In the early 1960s, Dalí lay on his favorite gravel beach in Cadaqués.

The sun was shining, a light breeze was wafting across the beach, and a beautiful woman was close by. It was Isabelle Dufresne, who—as "Ultra Violet"—would soon become Andy Warhol's muse and a pop-art superstar. But at such moments no creature was closer to Dalí than flies. They circled his moustache as if dancing the tango or flamenco. What was it about his moustache that exerted such a magical attraction on them? It was the unique scent of his whiskers, which Dalí had begun sculpting with the sweet, sticky juice of dates. As the strength of this homemade wax weakened over the course of the day, his whiskers underwent a wondrous transformation: "During the day, they are always gay, but at night they are sad. They are melancholy in the evening."

These metamorphoses of his moustache were like the metamorphoses of the coastal landscape by the Cap de Creus northeast of Cadaqués—a rocky landscape of slate and granite that

Philippe Halsman, photo from the series
Dalí's Mustache, 1954

is constantly being shaped into bizarre forms by the *tramuntana*, the area's typical northerly wind.

Dalí fell in love with this landscape as a child, and it appears in many of his most famous paintings. He once said that "every rock, every promontory of Cape Creus is in permanent metamorphosis. Each is a suggestion that prompts spontaneous visualization of an eagle, a camel, a rooster, a lion, a woman—but if you approach it from the sea, the nearer you get, the more the symbolism develops and changes. It is a continual simulacrum. The bird becomes a wild animal and then a barnyard fowl." Then he confesses: "Our life is a mimesis of the world. Our minds are like a film that records the variety of the phenomena of the universe. I am convinced that I am Cape Creus itself, that I embody the living nucleus of that landscape. My existential obsession is constantly to mimetize myself into Cape Creus. [...] My granite structure is equipped with ductilities, haze, glint, quicksands, that hide its needles, its craters, its promontories, the better to let me keep my secrets."

But how did Dalí hit upon the idea of using the sticky juice of the date as moustache wax? One day, a journalist asked him what he used to style his moustache. He answered spontaneously that he used "the glue secreted by dates." It was one of those claims that sprang spontaneously from his imagination, for at the time of the interview the only substance he applied on his moustache was his own saliva. But his statements often had a way of becoming reality until he actually did what he had once merely claimed to do. In his 1942 essay *Total Camouflage For Total War*, Dalí had proclaimed, "I believe in magic, which ultimately consists quite simply in the ability to render imagination in the concrete terms of reality."

The idea of smearing his moustache with a sticky-sweet substance in order to attract flies had been a wishful dream of his at least as far back as 1954. When Dalí and Philippe Halsman were putting together their legendary book *Dalí's Mustache*, Halsman asked him, "Dalí, what is your secret of success?" And Dalí answered, "Providing the right honey for the right fly at the right time and place."

The accompanying photograph showed Dalí's moustache drenched in honey, with a large fly stuck to his whiskers. **[fig. p. 122]** However, the photograph was made in Dalí's absence, since he had already returned to Europe. For the photo shoot, Halsman placed a copy of Dalí's moustache in front of a portrait of his and smeared it with honey. Since there are no flies in New York in winter, he went searching for spider webs, in which he actually managed to find some flies. But when Dalí saw the photograph, he was furious. The flies were too small; the picture needed a large horsefly. The next spring, a larger one was caught for the photograph, and Dalí was satisfied. While Dalí and Halsman were working on their photographic series for *Dalí's Mustache*, Dalí made a sensational discovery: He could use the tips of his moustache to paint. And what is the first thing that he painted with his moustache? A fly!

In the preface to *Dalí's Mustache*, he writes: "This very morning [...] I discovered that my mustache can serve as an ultra-personal brush. With the points of its hair, I can paint a fly with all the details of his hair. And while I am painting my fly, I think philosophically of my mustache, to which all the flies and all the curiosities of my era came to be monotonously and irresistibly stuck. Some day perhaps one will discover a truth almost as strange as this mustache—namely, that Salvador Dalí was possibly also a painter."

The tips of a moustache as a paintbrush! But what made for a nice motif in the book was difficult to implement in real life, because it forced him to lean his head too close to the picture. Still, the idea of a moustache paintbrush would not leave him alone, and soon he hit upon a solution. In August 1960, a newspaper reported that Dalí had made a brush out of his whiskers: "With this self-grown painting utensil, Dalí plans to produce portraits of famous individuals. Already, this enterprising artist has received so many commissions that he will be fully booked for the next five years."

Dalí felt his view confirmed after reading the story from *One Thousand and One Nights* in which a prince eats dates in order to find inspiration. To his great fortune, he soon discovered that the sticky juice of dates attracts flies. Now, when an elegant but "ordinarily pretty" woman addressed him because of his idiosyncratic moustache—which was not a rare occurrence—the following conversation ensued, as recorded in his *Diary of a Genius*. His fictitious conversation partner is simply named "Coccyx Woman," like the famous woman in his 1937 painting *The Burning Giraffe*, whose body is covered with drawers leading into her inner being.

Coccyx Woman: You have noticed perhaps that I haven't stopped staring at you. I think you are fascinating.
I, Dalí: So do I.
Coccyx Woman: Don't flatter me! You haven't even noticed me.
I, Dalí: I am speaking of myself, Madam.
Coccyx Woman: I keep wondering how you make your moustache point upwards.
I, Dalí: Dates!
Coccyx Woman: Excuse me?

I, Dalí: Dates. Yes, dates, the fruit of the date palm. At dessert, I ask for dates, I eat them, and before washing my fingers in the bowl when I have finished, I run them lightly over my moustache. That is sufficient to make it stand up.

Coccyx Woman: Oh!!!!!

I, Dalí: Another advantage is that the sugar of the dates inevitably attracts the flies.

Coccyx Woman: How horrible!

I, Dalí: I adore flies. I am only happy in the sun, naked and covered in flies.

Coccyx Woman: [...] But how is it possible to love being covered with flies? It is so dirty.

The conversation continues with Dalí emphasizing that he only likes clean flies—not those that have crawled over the faces of bureaucrats or that live in bourgeois homes, but those that have danced on the silver olive leaves of Port Lligat in their gray suits, as if they had been dressed by the Spanish fashion guru Balenciaga. André Breton hated these flies, because they annoyed him by their very presence during his visit to Port Lligat in the 1930s.

This love for flies could easily be considered unimportant if we didn't know of the deeper meaning that flies had for Dalí. He needed them so much that he even smeared the corners of his mouth with honey so that they would briefly fly into his mouth—which was always wide open with joy while painting. For Dalí, flies were not just the ultimate paranoiac-critical insect and a "hypersybaritic" pleasure—they were also "fairies of the Mediterranean," fairytale beings that, when they tickled him, helped to accelerate his thoughts.

Dalí was convinced that flies had brought ideas to the philosophers of Antiquity as well. And he had heard that the Huichol

Indians believe that people take on the form of flies after death in order to look back on their life until they are called by a shaman, to sit on his hand, and then finally fly towards the sun "to become one with it."

One afternoon, while Dalí was watching five flies circling a sea urchin, he imagined that he had discovered a new, even more profound mystery. Earlier that day, he had read a book according to which the Greek sculptor Phidias had designed a temple with a floorplan inspired by the five-sided shape of a sea urchin. Now, as Dalí observed the flies circling the urchin, he could "observe each time in their way of gravitation a spiral movement from right to left. If that law is confirmed, I have not the least doubt of its future: it will be as important for the cosmos as the law of Newton's famous apple, for I maintain that that fly everybody chases away contains within itself that quantum of action which God is forever putting under the very nose of people to show them insistently the way of one of the most hidden laws of the universe." Elsewhere, Dalí called flies ingenious, wise, and delirious – qualities that perfectly describe him as well. And so it only makes sense that he would say, "I am probably the only human being capable of seeing, and therefore thinking, like a fly."

But back to the beach at Cadaqués, where a swarm of flies is circling and tickling Dalí's moustache. If Isabelle Dufresne had not told the story at a symposium many years later, it would be hard to believe: Flailing wildly, the completely naked Dalí tried to shoo away the flies to the point of desperation. A note in Dalí's *Diary of a Genius* offers an idea as to why he reacted the way he did. Here he writes of his otherwise beloved flies: "That rarest of days when their presence bothers me is the sign that something is wrong and that the cybernetic mechanisms of my discoveries are grinding to a halt."

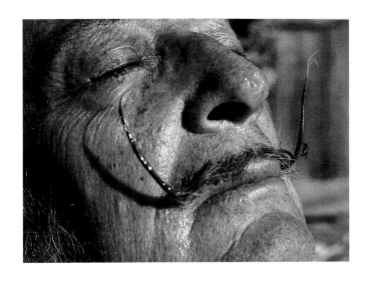

Enrique Sabater, *Dali with a Fly
on His Moustache*, 1974

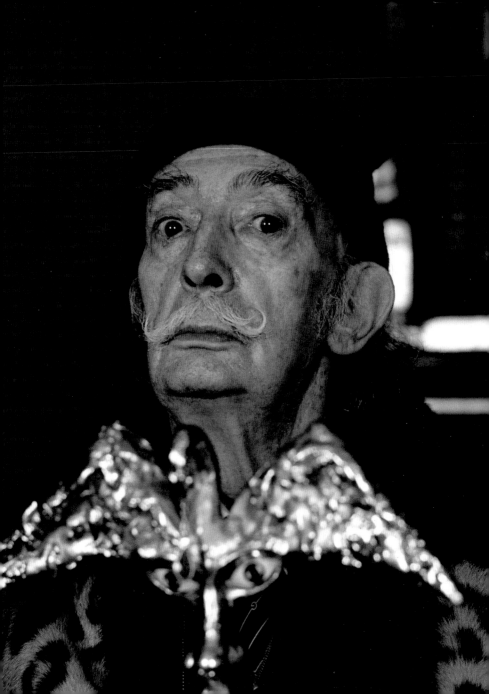

Dalí is Dead —
Long Live Dalí's Moustache!

The great lesson of Dalí's mustache is that
we all must patiently or impatiently grow within us something
that makes us different, unique and irreplaceable.
Philippe Halsman

Dalí did not want to die—at least, not for all eternity. Still, he knew that one day his body would fall apart. In the early 1970s he clung to the idea of having himself frozen or preserved in helium after his death, so that one day scientific progress, in which he steadfastly believed, might bring him back to life. For he was convinced that "to restore life will be an ordinary operation." Still, even though he had been born more than once during his lifetime, this possibility of a rebirth filled him with several concrete fears: "That mankind, possessed of a kind of murderous madness due to the bad effects of overpopulation [...] may start murdering the corpses. That the new life I some day wake up to may not be exactly mine, i.e., the divine Dalí body as it went to sleep: Would my unfreezing be a reanimation or rather the flowering of someone new, the birth of a Dalí I would not recognize? And that humanity by that time may have forgotten me, a risk which in fact seems rather slight, for my immortal oeuvre will only continue to become more

Manuel Litran, *Salvador Dalí*,
December 1980

131

meaningful, and my legend will add even more to the prestige of my genius."

But there was never just one genius, just one Dalí. There were several, though all of them wore Dalí's moustache. Dalí was many things: great Surrealist painter, object artist, action artist, stage designer, inventor, fashion designer, filmmaker, and screenwriter. He was a shy eccentric who believed that his muse and goddess, his beloved Gala, had helped him find the feminine aspects of his personality. He was the developer and apostle of the paranoiac-critical method; he gave form to fantastical worlds, the unconscious, the dreamlike and delirious; he was a photographer of souls who worked with paint and brush. In his mystical period since the late 1940s, he had tried to show what holds the world together at its core. At a time when everyone was looking for radically new forms and techniques in art, he looked back to pictures and techniques of the past, only to create something new in a hyper-realistic style—and thus helped to create Op-Art and Pop-Art. He was passionate about the latest scientific discoveries, and his art was as influenced by the dropping of the atomic bomb on Hiroshima as it was by the discovery of DNA or the invention of the hologram, which he used as an artistic medium in the 1970s. There was Dalí the artist who painted and splattered so freely in his book illustrations since the 1960s that one almost forgets that he was a predecessor to photo-realism. There was the Dalí who wanted to make Marilyn Monroe the Empress of China—in the 1960s when she was long dead—and retorted to the era's student movement that he would rename UNESCO the "Ministry of Public Cretinization," after which it would offer "folkloric prostitution." Dalí was all this and much more.

Dalí was also the highly paid artist, the money-obsessed egocentric showman for whom no appearance was beneath him, as long as there was money to be made. He was a mystical-philosophical or even religiously-tinged provocateur, the self-anointed savior of art who condemned nearly all abstract art. He was a monarchist pop star, a sadist and a pervert who had no taboos.

And there was the Dalí who expressed such incredibly disturbing views on dictators, communists, bodily secretions, and his own uniqueness that more than a few people turned their backs on him—some out of boredom, others out of disgust.

There was Dalí the artist who created so many graphic works and lithographs that the art world is still trying to figure out which were actually made by him. Or the artist who, in the 1960s when he was accused of making kitsch, joyfully announced his kitsch period. There was Dalí the inventor of melting clocks who wanted to see his art on coffee cups and pillowcases and who proclaimed in 1967 that "nothing is more appropriate in a box of pralines than the soft and melting clocks of Dalí, the Divine Dalí." He was an artist who was not afraid of the masses. And he was an artist for the masses whose Dalí Theatre-Museum, which he opened in Figueres in 1971 in order to display his art, competes with the Prado in terms of visitor numbers. Dalí was all this and much more.

Then there was Dalí the artist of the twentieth century, who wore a moustache when all other artists were clean-shaven; the Dalí who needed his moustache in order to become an artist, in order to become Dalí. And finally, there was Dalí the artist who turned his moustache into an art object and into an unmistakable trademark, just as Andy Warhol would do later with his blond wig and Joseph Beuys with his hat.

Dalí's final years were not easy. He had never been seriously ill, but in 1980 he came down with a serious flu following a prostate operation. He quickly grew afraid that he would never get well again, and fell into a deep depression. His biographer Ian Gibson later wrote that this was when Gala began to give him valium for his nerves and amphetamines for his mood—without any prescription or medical oversight. Dalí still loved Gala, although their relationship was increasingly marked by conflict. For several years, she had been bringing young lovers to Púbol Castle, the medieval home that Dalí had bought for her in 1970 and had decorated with his own murals.

Shortly after the flu, Dalí's right arm began to twitch. His doctors initially suspected Parkinson's disease; later, they thought that it might be related to his depression. In the end, he was diagnosed with arteriosclerosis. In October 1980, the visibly aged Dalí appeared at a press conference at his Dalí Theatre-Museum dressed as an eccentric dandy—wearing a leopard fur coat, with a Catalan barrita on his head, a cane with a golden handle, and a

Delta Air Lines plane with Dalí moustache, on
the occasion of an exhibit at the High Museum
of Art in Atlanta, 2011

thoroughly gray moustache. **[fig. p. 130]** His arrival was announced by Wagner's *Tristan und Isolde*. In 1982, Gala died at the age of eighty-nine. She was buried in her favorite red dress in the crypt at Púbol Castle. Shortly thereafter, King Juan Carlos bestowed upon Dalí the title of Marqués de Dalí y de Púbol. But so great was his mourning, and so profound his depression, that the eternal monarchist probably felt little joy on this occasion.

In 1983, Dalí painted what is considered his last painting, *The Swallow's Tail*. He probably needed help painting it, as his hand was so shaky. The painting looks like a sudarium on which the artist has painted geometric forms using just a few brushstrokes. At the center of the painting, two lines curve upwards resembling a swallow's tail. In this painting, Dalí referred to the catastrophe theory of mathematician René Thom, whom he had met several years earlier. Thom's theory distinguished several types of catastrophes, which he depicted using geometric diagrams. One of these resembled a swallow's tail, and so he called it the "swallowtail type." Dalí was excited by the aesthetics of this theory,

Tobias Schwarz, *Lady Gaga*
with Dalí Moustache, 2013

Hat (stylized Dalí moustache)
from Philip Treacy Collection, 2011

and after completing the painting he recognized in his moustache a three-dimensional expression of this catastrophe theory: "And just at that moment I realized with amazement that it is the divine form of the swallow's tail from the Upper Tertiary, which has been a constant in my life since childhood. This form was probably previously stressed by my own moustache, as can be seen on the photograph by Man Ray that appeared on the cover of Time in 1936." **[fig. p. 10]**

The year that he finished this painting, a small catastrophe happened at Púbol Castle. A fire broke out in the room of the bedridden Dalí. Although he repeatedly activated a signaling device attached to his arm in order to call for help, nobody came. Perhaps the device itself was responsible for the fire. Dalí managed to make it to the door of his room, but he suffered burns over eighteen percent of his already weakened body. After an operation, he moved into the Torre Galatea, a side wing of the Dalí Theatre-Museum.

Salvador Dalí died of heart failure on January 23, 1989. He was eighty-four years old. The embalmed body, preserved with seven liters of formaldehyde, was interred in the crypt at his Theatre-Museum in Figueres. A delicate moustache adorned his face, its few short, nearly white facial hairs twisted at the ends.

Dalí is dead, but his moustache lives on. He once said, "A painting by me is not much compared to the magic that is constantly emanating from me." No part of Dalí so immediately radiated magic as his moustache, because it is the one place where his personality found its perfect expression. And so Dalí's moustache continues to radiate with his magic—whether as reference, copy, or poetic citation. His moustache grew to become not just his trademark, but a symbol for Dalí himself. It is the

moustache of 1953, when it had reached its fullest dimensions—the one he wore for his rebirth in Rome the following year when he fully and completely became Dalí. This was the highpoint of his moustache metamorphoses, though it was hardly the end. This is the moustache that the world imagines when it thinks of Dalí's moustache, the one that has grown into the collective memory of mankind. It doesn't matter that Dalí first wore sideburns or a Menjou moustache and variations thereof. It doesn't matter that Dalí later cut back what had been the world's longest moustache or that, in the late 1960s, he briefly wore sideburns again. It doesn't matter that at some point his moustache grew thinner and changed color. Long live Dalí's moustache. Dalí's moustache lives!

The eternal life of Dalí's moustache probably began with the first copy that Dalí himself had his barber make so that he might cut it off in front of the media. But his moustache could be just as easily evoked by a rolled-up paper napkin, like the one Jean Cocteau stuck between his nose and upper lip when he met Dalí in the fall of 1953. **[fig. p. 139]** And naturally when the first Dalí impersonator, Henri Salvador, appeared on French television in 1964, he wore Dalí's trademark moustache.

By then, Dalí's moustache had even made an appearance in poetry—specifically, in the 1963 poem *The Path of the Dolphin Grasses* by the Austrian writer Friederike Mayröcker. And in Mayröcker's 1991 *Still-Life*, a man named Samuel wears the famous moustache in the chapter entitled *The Inclination of Rain*: "You wear a Dalí moustache on your left cheek, mysterious study of the body, forestations and hair growth on a breast, flowing hair, and a moustache pointing to the heavens. Again and again, Samuel speaks of his hairstyle, while he lets his hair grow long like a woman's, a female organ, I say, and a moustache pointing

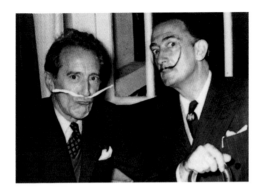

to the heavens; everything artistic about him has a feminine side, which is nice."

Today, Dalí's moustache can be found smiling everywhere: at parties, on t-shirts and coffee cups, in advertising, and even in the skies—for its Dalí exhibit from August 2010 to January 2011, the High Museum of Art in Atlanta placed a giant Dalí moustache on the nose of a Delta airplane. **[fig. p. 134]** His moustache has even appeared on women: when the Irish fashion designer Philip Treacy presented his 2011 collection, one of his models wore a very Dalínian head covering **[fig. p. 137]** that almost looked as if Treacy was showing the metamorphosis of Dalí's moustache into a swallow's tail. Two years later, a shorter version of the Dalínian moustache adorned the face of a woman, just as Amanda Lear had once done when she attended a costume party with Dalí. This time, it was the American pop star Lady Gaga, during the launch of her new album *Artpop*. **[fig. p. 135]** And in 2014 it almost seemed as if Dalí himself had risen from the dead, for a photograph by the American photographer Sandro Miller showed Dalí with wide-open eyes and upturned moustache. Or at least that's what

Unknown, *Salvador Dalí and Jean Cocteau*, Barcelona 1953

it looked like at first glance. **[fig. p. 141]** Upon closer inspection, it became clear that the photograph was part of Miller's project *Malkovich, Malkovich, Malkovich: Homage to Photographic Masters,* in which the actor John Malkovich appeared in copies of forty-one legendary pictures as, among others, Albert Einstein, Marilyn Monroe, Bette Davis—and Salvador Dalí. One of the chosen photographs was Philippe Halsman's famous portrait of Dalí that opens the series of interviews in *Dalí's Mustache.*

If Dalí were alive today and he saw all this, he would almost certainly go crazy from moustache happiness. After all, he once said that he wanted exactly 2,258 moustaches. Today there are many more. Dalí once told Philippe Halsman something that was both touching and shocking: "Many American tourists visited me this summer in Spain. Did they want to see my paintings? Not at all! They were only interested in my mustache." And then he added what sounds like the mission that Dalí's moustache, as something to remember and emulate, must fulfil for all eternity: "The public does not need great painting. What it needs is a better mustache."

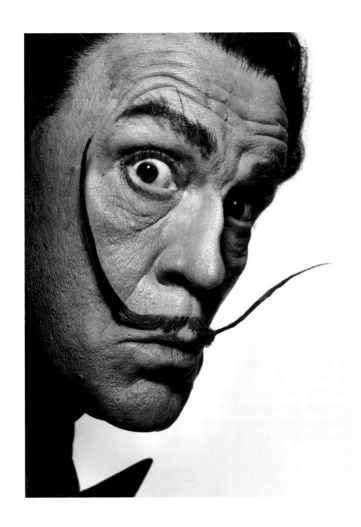

Sandro Miller (Philippe Halsman), John Malkovich re-enacts Philippe
Halsman's portrait of Dalí. From the series: *Malkovich, Malkovich,*
Malkovich: Homage to Photographic Masters, 2014

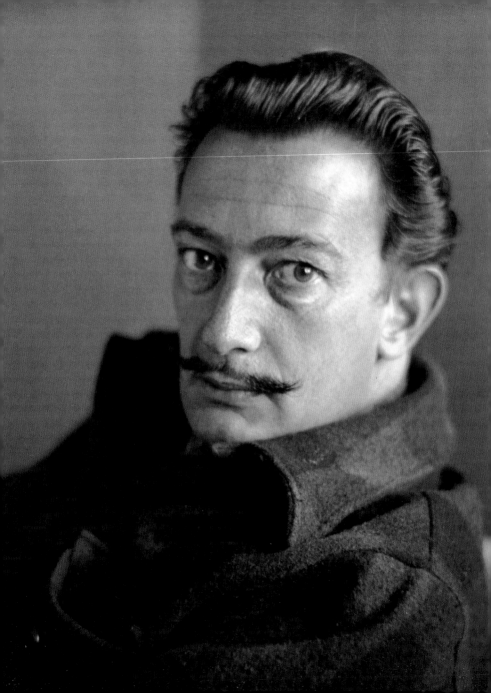

Biographical Chronology

I don't really care whether they think I'm a painter,
a TV personality, or a writer. The main thing is that the
Dalí myth still prevails, even when it's not understood
or when it's all wrong.
S. D.

1904
Salvador Felipe Jacinto Dalí i Domènech is
born on May 11 at 8:45 a.m. in the Catalonian
town of Figueres as the second son of the
notary Don Salvador Dalí i Cusí and his wife
Felipa Domènech Ferrés.

1908
Birth of Dalí's sister Ana María. Dalí attends the
municipal school in Figueres.

1912
The family moves into a house in Figueres
where Dalí sets up his first studio in the attic.

1916
In the fall, Dalí attends a private Roman
Catholic school run by the Marist Brothers in
Figueres. He also begins taking drawing lessons
from Juan Núñez Fernández (1877–1963) at the
municipal drawing school.

1921
Death of Dalí's mother.

1922
In October, Dalí begins to study painting at the
San Fernando Academy in Madrid, where he
moves into a room at the Residencia de
Estudiantes. Beginning of his friendship with
Federico García Lorca and Luis Buñuel.

1923
Dalí is held responsible for student unrest at
the art school and is expelled for one year. He
returns to Figueres.

1924
In May, Dalí is arrested for supposed political
reasons and spends several weeks in prison. In
September he resumes his studies in Madrid.

1926
Dalí refuses to take an end-of-year exam
because of the testing committee's "incompe-
tence," and is expelled from the academy.

1927
In February, Dalí begins his mandatory military
service. In July, he publishes his essay *San
Sebastián*, which is dedicated to Lorca. Joan
Miró visits Dalí at his studio.

1929
Starting in January, Dalí and Buñuel work on
the script of their joint film project, *Un Chien
Andalou*. From April to June Dalí is in Paris, where
Joan Miró introduces him to the Surrealists, who
soon officially accept Dalí as a member of their
group. In the summer, Paul Éluard and his wife
Gala (born Elena Ivanovna Diakonova on August
26, 1894) visit Dalí. Gala and Salvador fall in love
and move in together, causing a rift between Dalí
and his father.

Johan Hagemeyer,
Salvador Dalí, May 27, 1944

1930

In March, Dalí buys a fisherman's hut in Port Lligat on Spain's Costa Brava, which he gradually expands over the years. Dalí first mentions his paranoiac-critical method in the book *La femme visible*.

1934

Dalí and Gala marry in a civil wedding in January. In February, André Breton moves to expel Dalí from the Surrealist group. In December, Dalí and Gala take their first trip to America.

1935

In January, shortly before Dalí's return to Europe, Caresse Crosby organizes the *Dream Betrayal* masquerade ball for Dalí and Gala in New York. Dalí publishes *The Conquest of the Irrational*, in which he expounds at length on his paranoiac-critical method.

1936

In December, Dalí and Gala embark on their second voyage to New York. Also that month, *Time* Magazine publishes a photograph of Dalí on its cover.

1937

After a February visit to Hollywood, where Dalí meets several public figures including Harpo Marx, he returns to Europe.

1938

Dalí visits Sigmund Freud in London.

1939

In February, Dalí and Gala travel to New York. In March, he designs a window display for New York's Bonwit Teller department store. In July, after he is not allowed to realize a design for the New York World's Fair, he publishes his *Declaration of the Independence of the Imagination and the Rights of Man to His Own Madness*. In September, he and Gala travel back to Europe.

1940

In June, Dalí and Gala leave France via Portugal for their American exile.

1941

Dalí first meets the photographer Philippe Halsman.

1942

Dalí's autobiography *The Secret Life of Salvador Dalí* (written with a hefty dose of the imagination) is published by Dial Press in New York.

1945

The dropping of the atomic bomb on Hiroshima in August ushers in Dalí's "nuclear period," which soon becomes his "mystical period." Publication of the first issue of *Dalí News, Monarch of the Dailies*.

1946

Dalí and Walt Disney begin collaboration on the animated film *Destino*.

1948
Dalí publishes the book *50 Secrets of Magic Craftsmanship*. In July, Dalí and Gala return to Port Lligat from their American exile.

1951
Dalí publishes his *Manifeste Mystique* (*Mystical Manifesto*) in Paris.

1952
Death of Dalí's father, with whom he had previously reconciled.

1953
Dalí and Philippe Halsman start work on their book *Dalí's Mustache*.

1954
In June, Dalí emerges from a "metaphysical cube" during a press conference for his exhibition at the Palazzo Pallavicini-Rospigliosi in Rome: an event intended to symbolize his rebirth. In October, *Dalí's Mustache* is published by Simon and Schuster in New York.

1958
Dalí and Gala have a church wedding.

1960
Despite many Surrealists' protests, Dalí participates in the International Surrealist Exhibition in New York.
Dalí meets Isabelle Dufresne (1935–2014), who will become both his model and companion. She will later gain international fame under the stage name Ultra Violet and as Andy Warhol's muse.

1964
Spain's dictator Francisco Franco awards Dalí the Great Cross of Queen Isabella, one of the country's highest honors.

1965
In the fall, Dalí meets Amanda Lear (born 1939 or 1946), who becomes his model and close friend.

1968
In response to the student unrest in Paris, Dalí writes the pamphlet *My Cultural Revolution*.

1974
Opening of the Dalí Theatre-Museum in Figueres.

1982
Gala dies on June 10. In July, King Juan Carlos awards Dalí the noble title of Marqués de Dalí y de Púbol.

1984
Dalí suffers severe burns during a fire at Púbol Castle, where he has been living since Gala's death. In October, he moves to the Torre Galatea at his Theatre-Museum, where he will spend the rest of his days.

1989
Dalí dies of heart failure on January 23 at 10:15 a.m.

Literature
(selected and recommended)

Daniel Abadie, *La vie publique de Salvador Dalí*, Paris 1979.

Manuel del Arco (ed.), *Salvador Dalí. Ich und die Malerei*, Zurich 1959.

Rudolf Augstein (ed.), *Der Spiegel*, 1 / 1961 (1.1.1961), Hamburg 1961. See: "Salvador Dalí. Avida Dollars" pp. 39–50.

Anne Breucha, *Die Kunst der Postproduktion. Jeff Koons in seinen Interviews*, Paderborn 2014.

Luis Buñuel, *An Unspeakable Betrayal: Selected Writings of Luis Buñuel*, Berkeley (CA) 2002.

Fleur Cowles, *The Case of Salvador Dalí*, New York 1959.

Robert Craft, *Stravinsky: Chronicle of a Friendship*, Nashville (Tn) 1994.

Salvador Dalí, *So wird man Dalí*, Wien, Munich, Zurich 1974.

Salvador Dalí, *The Secret Life of Salvador Dalí*, New York 1942.

Salvador Dalí, *Diary of a Genius*, Chicago (Mass.) 2007.

Salvador Dalí, *Meine Leidenschaften*, Munich 1989.

Salvador Dalí, *Oui: The Paranoid-critical Revolution : Writings, 1927–1933*, ed. by Robert Descharnes, Ann Arbor 1998.

Salvador Dalí, *The Collected Writings of Salvador Dalí*, ed. by Haim Finkelstein, Cambridge (Mass.) 1998.

Salvador Dalí, *50 Secrets of Magic Craftmanship*, Mineola, New York 1992.

Salvador Dalí / Philippe Halsman, *Dalí's Mustache*, Paris 1982.

Fundació Gala-Salvador Dalí / Sociedad Estatal de Conmemoraciones Culturales (ed.), *Salvador Dalí. An illustrated Life*, London 2007.

Yasha David / Kunst und Ausstellungshalle der Bundesrepublik Deutschland (ed.): *¿Bunuel! Auge des Jahrhunderts*, Bonn 1994.

Robert Descharnes, *Dalí. Sein Werk – sein Leben*, Cologne 2003.

– *Dalí. Das malerische Werk*, Cologne 2013.

Péter Egri, *Modern Games with Renaissance Forms. From Leonardo and Shakespeare to Warhol and Stoppard*. From the series: *Studies in Modern Philology*, 12, Budapest 1996.

Meredith Etherington-Smith, *The Persistence of Memory: A Biography of Dalí*, Boston (Mass.) 1995.

Fèlix Fanés, *The Construction of the Image, 1925–1930*, New Haven 2007.

Anna Feldhaus, *Salvador Dalí & Philippe Halsman. Das gemeinsame Werk*, Heidelberg, Berlin 2015.

Johannes Fiebig, *Dalí Tarot*, Kiel 2003.

Ian Gibson, *Salvador Dalí. Die Biographie*, Stuttgart 1998.

G. Barry Golson (ed.), *The Playboy Interview*, Vol. II. See: *Salvador Dalí* (Interviewer: Sterling McIlany), S. 27–37, New York 1983.

Anne D'Harnoncourt / Kynaston McShine (ed.), *Marcel Duchamp*, Munich 1989.

Richard P. Hartmann (ed.), *Hommage à Dalí. Mit den Gesprächen zwischen Alain Bosquet und Salvador Dalí*, Munich 1974.

Hugh M. Hefner (ed.), *Playboy*, no 4, April 1979. See: *Playboy Interview* (with Lluis Permanyer): *Dalí*. pp. 55–66, Munich 1979.

Gustav René Hocke, *Die Welt als Labyrinth. Manierismus in der europäischen Kunst und Kultur*, Reinbek bei Hamburg 1987.

Institut de Cultura del Ayuntamiento de Barcelona (Hg.), *El ojo invisible, Enrique Sabater fotografía a Salvador Dalí*, Barcelona 2004.

Stan Lauryssens, *Dalí & I. The Surreal Story*,
New York 2008.
Robert S. Lubar, *Dalí. The Salvador Dalí Museum
Collection*, Boston, New York, London 2000.
Amanda Lear, *My Life with Dalí*, London 1985.

Conroy Maddox, *Salvador Dalí 1904–1989.
Exzentrik und Genie*, Cologne 1993.
Axel Matthes / Tilbert Diego Stegmann (ed.),
*Salvador Dalí. Unabhängigkeitserklärung
der Phantasie und Erklärung der Rechte des
Menschen auf seine Verrücktheit. Gesammelte
Schriften*, Munich 1974.
Manifestoes of Surrealism, Ann Arbor 1969.
Karin von Maur, *Salvador Dalí 1904–1989*,
cat. Staatsgalerie Stuttgart, Kunsthaus Zürich,
Stuttgart 1989.
Friederike Mayröcker, *Gesammelte Gedichte
1939–2003*, Frankfurt am Main 2004.
–, *Stilleben*, Frankfurt am Main 1991.
Richard Mas Peinado, *Dalí. Leben und Werk*,
Petersberg 2004.

Antonio Pitxot / Montse Aguer, *Museumshaus
Salvador Dalí Port Lligat*, Barcelona 1998.

Michael Elsohn Ross, *Salvador Dalí and the
Surrealists. Their Lives and Ideas. 21 activities*,
Chicago (Mass.) 2013.

Linde Salber, *Salvador Dalí*, Reinbek bei
Hamburg 2004.
Jörg Scheller / Alexander Schwinghammer (ed.),
*Anything Grows. 15 Essays zur Geschichte, Ästhetik
und Bedeutung des Bartes*, Stuttgart 2014.
Ralf Schiebler, *Dalí. Die Wirklichkeit der Träume*,
Munich, Berlin, London, New York 2004.
Uwe M. Schneede, *Die Kunst des Surrealismus.
Malerei, Skulptur, Dichtung, Fotografie, Film*,
Munich 2006.
Walther Hermann Schünemann (ed.),
*Da Da Dalí. Salvador Dalí in Bildern von
Werner Bokelberg*, Bielefeld, 2004.

Meryle Secrest, *Salvador Dalí. Sein
exzentrisches Leben – sein geniales Werk –
seine phantastische Welt*, Munich 1989.
Gertrude Stein, *Everybody's Autobiography*,
Exact Change 1993.
Sam Stourdzé / Anne Lecoste, *Philippe
Halsman. Astonish Me!*, Munich, London,
New York 2014.

Michael R. Taylor, *The Dalí Renaissance.
New Perspectives on His Life and Art after 1940*,
New Haven, London 2008.
Clifford Thurlow, *Sex, Surrealism, Dalí and Me.
The Memoirs of Carlos Lozano*, Leipzig 2013.

Ingo F. Walther (ed.), *Salvador Dalí. Retrospektive
1920–1980, Gemälde, Zeichnungen, Grafiken,
Objekte, Filme, Schriften*, Munich 1980.

Other Media

Dalí's screen presence at *The Name's the Same*,
January 19, 1954: https://www.youtube.com/
watch?v=78SiVt-zFzk
Dalí's screen presence at *The Name's the Same*,
January 3, 1955: https://www.youtube.com/
watch?v=RfjBO4JaXHc
Dalí's screen presence at *What's my Line?*,
January 27, 1957: https://www.youtube.com/
watch?v=w2ufpTDS7hE
Dalí's screen presence at *I've got a secret*,
February 25, 1963: https://www.youtube.com/
watch?v=GGFZh1h3rkI
Dalí's TV-advertisment for Chocolat Lanvin,
1970: https://www.youtube.com/
watch?v=bKeLX1AztZg
Dalí's film *Destino* for Walt Disney,1948/2003:
https://www.youtube.com/
watch?v=1GFkN4deuZU

All sites visited June 23, 2016.

Illustrations

Page 89 André Breton et al., *We don't EAR it that way*, 1960, made using a detail from the 1952 painting *Assumpta Corpuscularia Lapislazulia*
© Salvador Dalí, Fundació Gala-Salvador Dalí/ VG Bild-Kunst, Bonn 2016
Association Atelier André Breton, www.andrebreton.fr
© VG Bild-Kunst, Bonn, 2016

Page 90 Giancarlo Botti, *Salvador Dalí and Amanda Lear*, 1960s
© Giancarlo BOTTI/Gamma-Rapho via Getty Images

Page 92 Liselotte Strelow, *Salvador Dalí with Nietzschean Moustache*, 1953
Photo: Grisebach, Berlin; © Gesellschaft Photo Archiv e.V. Bonn/VG Bild-Kunst, Bonn 2016

Page 94 Nietzsche with walrus moustache, undated
Photo: Bettmann/Getty Images

Page 97 Roger Higgins, *Mr. Salvador Dalí with his Ocelot Babou at The St. Regis, New York*, 1965

Page 98 Pinaud moustache wax with brush

Page 100 Willy Rizzo, *Salvador Dalí*, 1966
© Willy Rizzo/Paris Match via Getty Images

Page 105 *John Lennon and his wife of a week Yoko Ono in their bed in the Presidential Suite of the Hilton Hotel, Amsterdam, March 25, 1969*
© Keystone/Hulton Archive/Getty Images

Page 106 Charles Hewitt, *Larger Than Life*, 1955
© Charles Hewitt/Getty Images

Page 108 Monsieur Marquay *perfume flacon designed by Dalí*

Page 109 *Artistic carpet by Manufacture d'Aubusson with moustache motif from 1950*
Photo: akg-images/François Guénet

Page 111 *Still from the Goodson-Todman game show* The Name's the Same (January 3, 1955)

Page 112 *Advertising poster for* Chocolat Lanvin *featuring Dalí*, 1968

Page 114 Paul Popper, *Salvador Dalí Cutting his Mustache*, 1964
© Paul Popper/Popperfoto/Getty Images

Page 117 Philippe Halsman, *Salvador Dalí's Performance with Helicopter at Port Lligat*, 1964
© and photo: Philippe Halsman / Magnum Photos / Agentur Focus

Page 118 Werner Bokelberg, *Salvador Dalí Coloring His Moustache at Port Lligat*, 1965
© Werner Bokelberg

Page 121 Gianni Ferrari, *Dalí on Spanish Television*, 1969
© Gianni Ferrari/Cover/Getty Images

Page 122 Philippe Halsman, *photo from the series* Dalí's Mustache, 1954
Photo: Philippe Halsman / Magnum Photos / Agentur Focus

Page 129 Enrique Sabater, *Dalí with a Fly on His Moustache,* 1974
© Enrique Sabater

Page 130 Manuel Litran, *Salvador Dalí,* December 1980
© Manuel Litran/Paris Match via Getty Images

Page 134 *Delta Air Lines plane with Dalí moustache, on the occasion of an exhibit at the High Museum of Art in Atlanta,* 2011

Page 135 Tobias Schwarz, *Lady Gaga with Dalí Moustache,* 2013
Photo: REUTERS/Tobias Schwarz

Page 136 *Hat (stylized Dalí moustache) from Philip Treacy Collection,* 2011

Page 139 Unknown, *Salvador Dalí and Jean Cocteau,* Barcelona 1953
Photo: Piero Biasion

Page 141 *Sandro Miller (Philippe Halsman), John Malkovich re-enacts Philippe Halsman's portrait of Dalí. From the series:* Malkovich, Malkovich, Malkovich: Homage to Photographic Masters, 2014
© Sandro Miller/Courtesy Catherine Edelman Gallery, Chicago

Page 142 Johan Hagemeyer, *Salvador Dalí,* May 27, 1944
© Johan Hagemeyer, courtesy The Bancroft Library

Unless otherwise indicated, the illustrations are from the archives of the author and the publisher. The publisher has endeavored to locate all the holders of copyright. Please inform the publisher in case of any omissions in this regard.

© Prestel Verlag, Munich · London · New York, 2016
A member of Verlagsgruppe Random House GmbH
Neumarkter Straße 28, 81673 Munich

For copyrights of illustrations
see *Illustrations*, pp. 148–151

Translation from German: Stephan von Pohl
Editorial director and editing: Nicola von Velsen
Picture selection: Boris Friedewald
Picture editor: Dorothea Bethke
Copy editing: Megan Bedell and Sarah Quigley
Illustrations for endpapers: Kathrin Jacobsen
Design and layout: Kathrin Jacobsen
Production: Friederike Schirge
Origination: Reproline Mediateam GmbH, München
Printing and binding: DZS Grafik, d.o.o., Ljubljana
Paper: Condat matt Perigord
Printed in Slovenia

Verlagsgruppe Random House FSC® N001967

ISBN 978-3-7913-8255-5

Printed in Slovenia

WWW.PRESTEL.COM

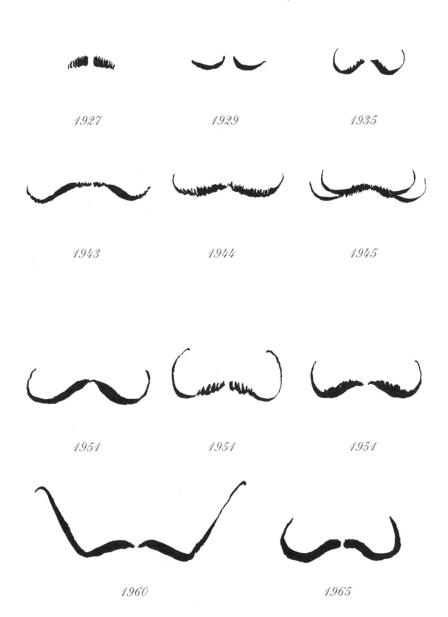

1927

1929

1935

1943

1944

1945

1951

1951

1951

1960

1965